IMAGES
of America

VISITING THE
GRAND CANYON
VIEWS OF EARLY TOURISM

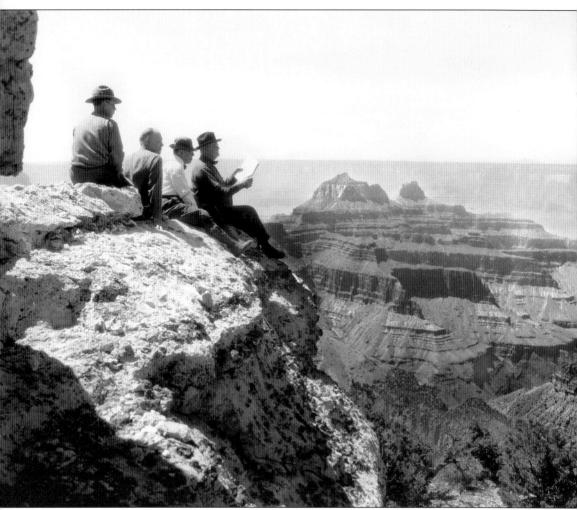

The Grand Canyon is indeed grand . . . and then some! Initially, some living back east would have difficulty believing such a place existed; a place beyond time; a place perhaps mirroring in its splendor the very creation of the planet itself. But the word spread; those spreading it became believable; and people began to feel the lure of the West pulling at their adventurous, pioneering heartstrings.

Imagine what these men must have felt like to be among the first people to gaze out upon this otherworldly scene at Bright Angel Point, with Osiris Temple and North Rim in the distance. Nowhere else in their travels had they come upon what could only be described as a sea of majestic canyons, replete in every color of the spectrum, stretching as far as the shaded eye could see . . . to where the distant horizon brushes gently up against the blueness of the sky above. (Photo by George Beam, courtesy of the Denver Public Library, Western History Collection, call number GB-5576.)

IMAGES
of America

VISITING THE
GRAND CANYON
VIEWS OF EARLY TOURISM

Linda L. Stampoulos

ARCADIA

Published by Arcadia Publishing
Charleston SC, Chicago IL, Portsmouth NH, San Francisco CA

Printed in Great Britain

Library of Congress Catalog Card Number: 2004104886

For all general information contact Arcadia Publishing at:
Telephone 843-853-2070
Fax 843-853-0044
E-mail sales@arcadiapublishing.com
For customer service and orders:
Toll-Free 1-888-313-2665

Visit us on the Internet at www.arcadiapublishing.com

*In honor and loving memory of Georgene Scott, who served as a rainbow of color in my life.
It was my privilege to know this courageous and inspiring woman who demonstrated that
strength can be found in family, love, and endless giving.*

CONTENTS

ACKNOWLEDGMENTS

First and foremost, I would like to thank Colleen L. Hyde, museum technician of the National Park Service, for her constant support with this project. Her excellent knowledge of the Grand Canyon National Park's Museum Collection helpfully guided me through the archives. I also thank Colleen for her cheerful smile and gracious service in providing these photographs.

Thanks to Barbara Dey and Becky Lintz, reference librarians with the Colorado Historical Society in Denver, for their prompt and efficient assistance.

Special thanks to Bee Valvo, Jill Koelling, Karen Underhill, and Susan McGlothlin, library specialists with the Cline Library of Northern Arizona University, for helping me obtain the historical images needed for this work.

I would like to thank Coi E. Drummond-Gehrig and Trina Purcell, of the Western History Collection of The Denver Public Library. They made the task of obtaining vintage photographs pleasurable.

I also express my appreciation to Carol Zegarac and the other family members of David Humphrey Scott of Cleveland, Ohio. During the research for our first book, it was David and his wife, Georgene, who introduced Kenny Shields and me to the marvelous collection of photographs taken by David's father, Dudley. They and their children took the time to give us the insight needed to fully appreciate the work of Dudley and his wife, Louise.

Special thanks to the family of Edward and Margaret Aschoff for allowing me to use the images from the late Edward Aschoff's collection.

My sincere appreciation is extended to Christine T. Riley with Arcadia Publishing for her cooperation and helpful suggestions throughout the months of this project.

I would like to thank my husband Scott for his review and word processing assistance. His editing comments helped make writing the book an enjoyable experience. Thanks too, to my son Evan for his technical contributions to this work.

Unless otherwise credited, all images were provided courtesy of the Grand Canyon National Park Museum Collection [GCNP] and are identified by an image number.

INTRODUCTION

The Grand Canyon National Park is located in northern Arizona. It is indeed one of the scenic marvels of the world. It shares its unmatched beauty such wonders as petrified forests and centuries old cave dwellings. Nowhere else can one climb the summits of snow-tipped mountains, explore the depths of wondrous canyons, experience breath-taking sunsets, or follow a mysterious trail to the past. The less adventurous visit the canyon for its endless vistas, relaxing strolls along its rim, or to shop in the most unique curio stores in the world.

It is hard for one to believe that little over a century ago, this land was relatively unexplored, practically unreachable by normal transportation, and as empty as it was vast. Although home to several Native-American tribes, the Grand Canyon and the lands surrounding it were an empty and untouched landscape, a blank spot on the maps of North America. It lay far removed from the population centers and major routes of travel.

By the 1880s, people realized the potential of this diverse land and began to tap its resources. Ranchers and prospectors moved into the region. Travel, for the most part, was restricted to mule, horse, or stage. Early travelers had no fast and easy means of transportation available.

The rough terrain, the lack of water, and the scarcity of minerals made prospecting a short-term career. Miners soon realized that there was little profit in transporting their ore by wagon, and it was not long before these pioneers set their sights on the increasing number of visitors to the canyon. Some used old mining claims to stakeout campsites and tenting grounds. Others looked to the livery business and began stage routes and halfway-house rest stops.

All this time, the railroad and its own set of business partners were also moving west. However, unlike the railroad, early pioneers arrived at the Grand Canyon penniless. They could only make improvements as they earned money from odd jobs. With little money to pay a "staff," they often worked alone with their families to build, prospect, mine, advertise, and guide. Another factor contributing to the slow growth of the pioneer businessman was the universal need to develop water sources. While the railroad could haul thousands of gallons of fresh water in tank cars, the pioneers were left to construct cisterns, catch snowmelt, and collect runoff from severe thunderstorms.

Early days of tourism at the canyon were unrestricted. Prior to automotive camping in the mid-1920s, most visitors stayed in concessionaire accommodations. However, nothing prevented families, prospectors, and others from setting up camp anywhere they chose. Cattle, mules, and horses grazed freely throughout the village up to the canyon's edge. Visitors from the large cities were unaccustomed to the large animals, their scents, and the flies they attracted.

Things began to change when the United States Forest Service and its rangers implemented some degree of regulation between the years 1905 and 1919. By 1910, most residents of the South Rim, other than those associated with the Santa Fe Railroad and the Fred Harvey Company, held a determined dislike for the United States Forest Service. One by one, pioneer-run hotels and camps on the rim began to close. In 1919, an act of Congress created the Grand Canyon National Park, to be regulated by the Department of Interior's National Park Service, which still oversees the park today.

While some locals abandoned their tourist trade, the Kolb brothers were persistent. Ellsworth and Emery Kolb set up a photography business in 1903 on the South Rim at the head of Bright Angel Trail. They would continue to operate there until Emery's death in 1976. For almost 75 years they created a remarkable visual history of the canyon. Visitors are still drawn to the Kolb Studio, now listed in the National Historic Register. The Kolb brothers epitomized the Grand Canyon pioneer spirit. Their love of adventure and their remarkable confidence marked the resolve of their generation, a generation of pioneers.

The following pages present a pictorial account of the early years of tourism at the Grand Canyon. Our trip begins with images of early travelers, who had forsaken all creature comforts to journey to the most wondrous sight in the world. Through pictures and words, we chronicle how these visits impacted the lives of these original tourists and those who would follow in their footsteps. Also presented are images of some of the more outstanding of the Grand Canyon pioneers and their attempts at making a profit from the tourist trade. The book concludes by honoring the canyon's earliest inhabitants, our American legacy.

One
GO WEST!

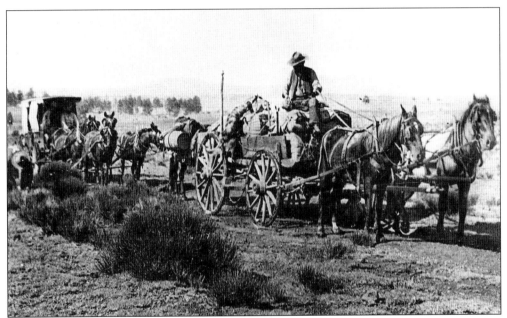

A traveler accounts of his trip from Flagstaff to the Grand Canyon in the summer of 1891:

> No work had been done on the road: it is made simply by driving over it. There are a few miles here and there of fair wheeling, but a good deal of it is intolerably dusty or exceedingly stony, and progress is slow. It is a tiresome journey of two days. The trip was so hard that a day of rest is absolutely required at the canyon, so that five days must be allowed for the trip. This will cost the traveler from forty to fifty dollars.

So it was, that in 1891, the demand for a railroad from Flagstaff to the Grand Canyon began to increase. Pictured are two wagons on their way to the canyon. (GCNP #15940.)

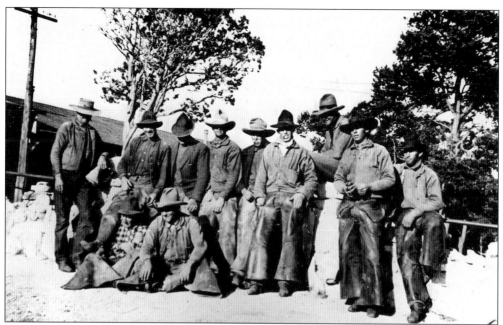

In the 1880s the land around the Grand Canyon was ordinary federal domain with no special status. It was open to homesteading, mining, lumbering, grazing, and any other use. It had never been surveyed, so with very few identified holdings, the settlers simply helped themselves. Here, 11 wranglers pose near Bright Angel Camp. (Courtesy of Grand Canyon National Park, #17446.)

By 1890, travel to the Grand Canyon had become quite brisk. Despite rustic hardships and difficulties, enough people were taking trips to the canyon that the potential of tourism could be seen. This group set up camp in 1905. (Courtesy of Grand Canyon National Park, #15834.)

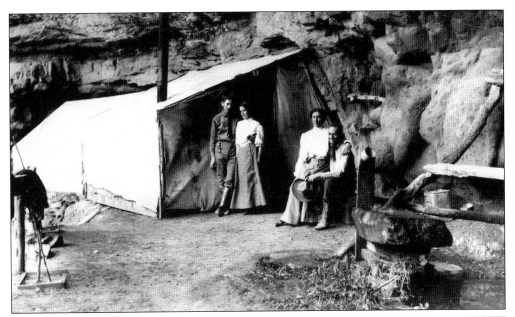

Drawn by a single team, a wagon leaving Flagstaff could only advance about 4 miles per hour and cover perhaps 35 miles in a day. This meant that travelers from Flagstaff to the Grand Canyon had to spend at least one night on the road, camping out under the stars or in tents, packing bedrolls and camping equipment for such purpose. Two couples pose in front of their tent camp. (GCNP #15760.)

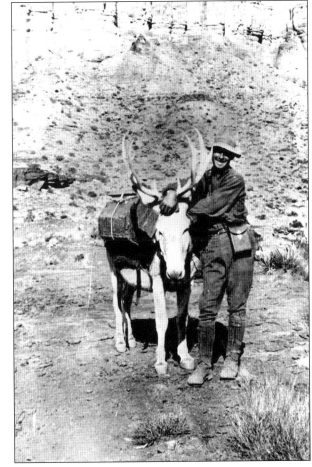

A sense of humor was almost always a necessity when traveling for days through rough terrain. Here, a man playfully holds a set of antlers on a burro's head. (GCNP #17443.)

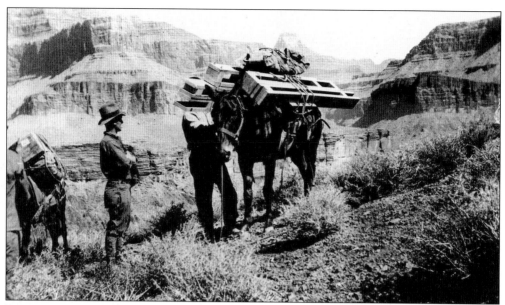

Burros were seemingly born for canyon life. Here, two men load their gear onto a very docile animal. (GCNP #17432.)

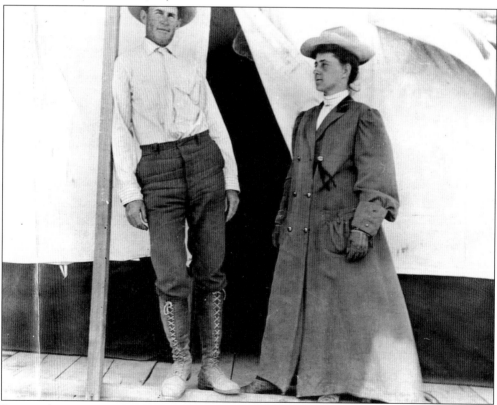

Even in the expansive canyon, social norms were not to be ignored in 1907. A couple in riding clothes poses in front of their tent cabin at Cameron (or Bright Angel) Camp. Note the formal shirt and tie. (GCNP #15797.)

Stockades kept animals safe and secure. To go west required reliable transportation, and for those without an early automobile, the term "horsepower" was taken literally. Note the expressions of determination on the faces of these early 1905 pioneers. (GCNP #15837.)

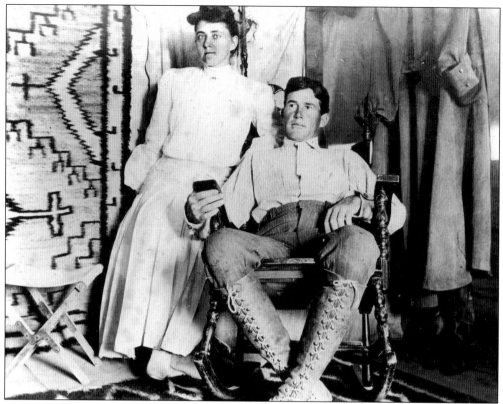

Posing inside a tent cabin, this couple's pride reflects the attitude of the wealthy, who visited the canyon in 1907. Note the Navajo rugs on the floor and the wall. (GCNP #15798.)

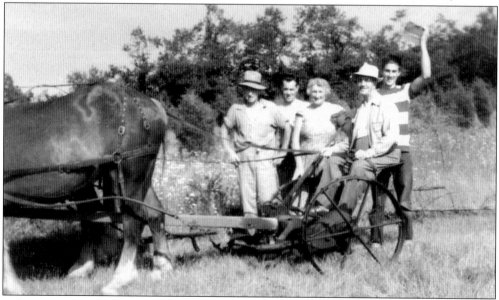

Reliance on animals for transportation as well as for planting and harvesting was well known in the great Southwest. A multi-generational family poses behind the family plow. (Courtesy of the late Edward Aschoff.)

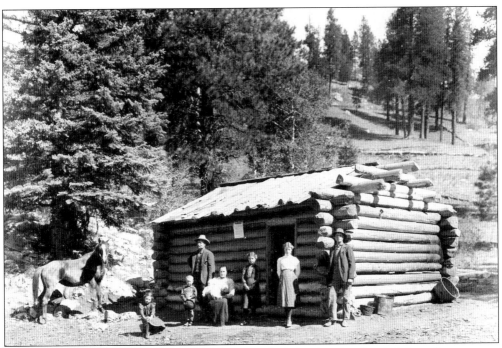

For families who homesteaded, life could be particularly hard as they heeded the call to go west. In this photograph dated 1900, a homestead family on the canyon rim stands by their timber cabin. It does not take much imagination to realize the difficulties they must have encountered. (GCNP #17762.)

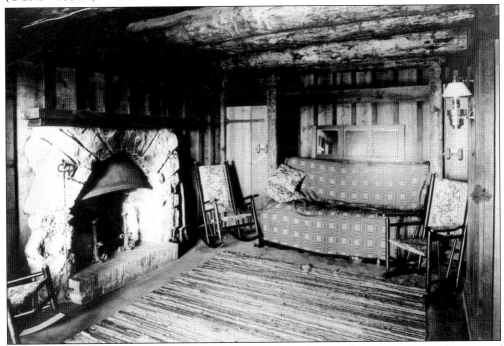

For tourists, living conditions were somewhat crude and rustic, but not without elements of charm. Note the fireplace, rocker, and pillow-filled couch. (GCNP #11431.)

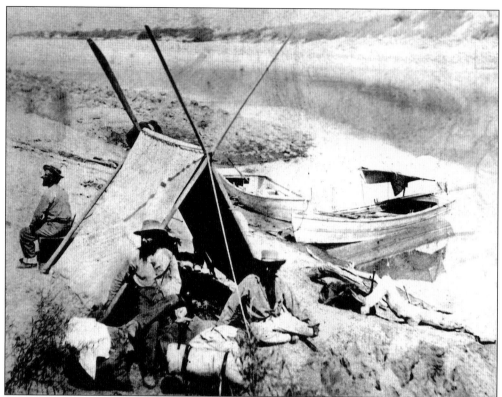

These bearded men in full-brim hats are members of an 1871 survey crew. They pose at camp beside the Colorado River in what would later be the Grand Canyon National Park. (Photo by T. O'Sullivan, courtesy of the Denver Public Library, Western History Collection, call number Z-7875.)

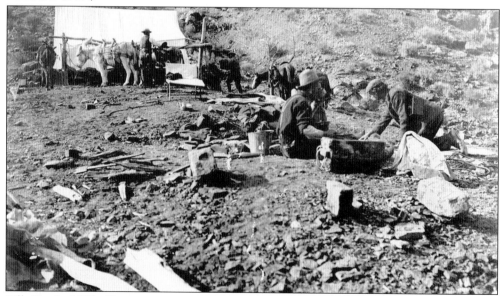

Bill Bass's 1900 Shinumu tent camp was located two miles north of the river on Shinumu Creek. (GCNP #17752.)

Canyon "explorer" Dudley Scott offers shade to his automobile in 1929. The vehicle is parked at the headquarters of Lees Ferry deputy sheriff, Mr. C.H. Moon. (Courtesy of the Dudley Scott collection, GCNP #6756.)

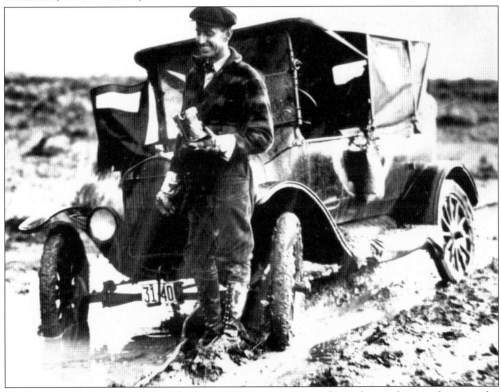

Mud could foil even the best of drivers. A 1929 tourist is stuck on the road somewhere on the way to the canyon in Arizona. Not much to smile about in this predicament. (Courtesy of the Dudley Scott collection, GCNP #6798.)

17

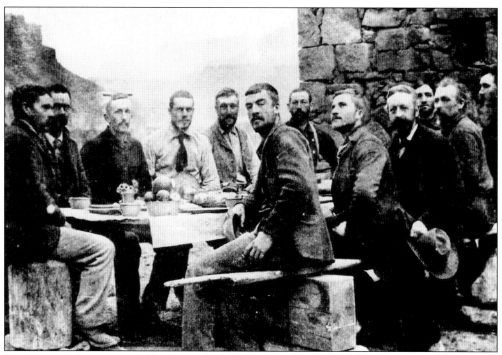

Members of the Stanton Expedition Crew enjoy an 1889 Christmas Dinner at Lees Ferry. (Courtesy of Grand Canyon National Park, #18443.)

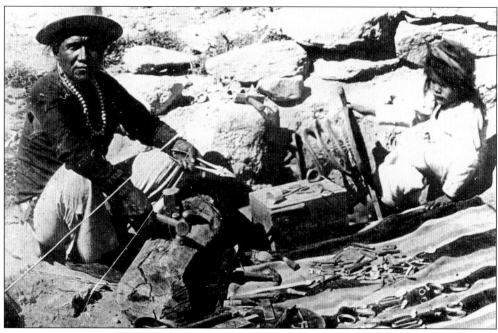

Travelers often met Navajo craftsmen selling their wares. In this photo dated 1915, a Navajo silversmith displays his complete set of tools on a blanket. (Courtesy of Grand Canyon National Park, #15926.)

By 1910, the automobile was becoming a more and more familiar sight across America. In this photo, men tend to their means of transportation at the canyon's rim: a horse . . . and a horseless carriage. (GCNP #15753.)

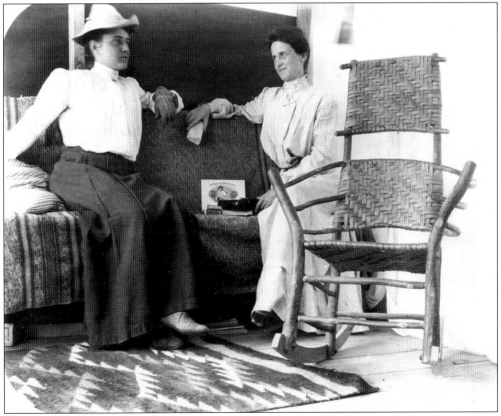

This is an excellent 1907 view of how cozy the inside of a tent cabin could be. These women enjoy both comfortable furniture and warm surroundings. Pay special attention to the handcrafted chair. (GCNP #15799.)

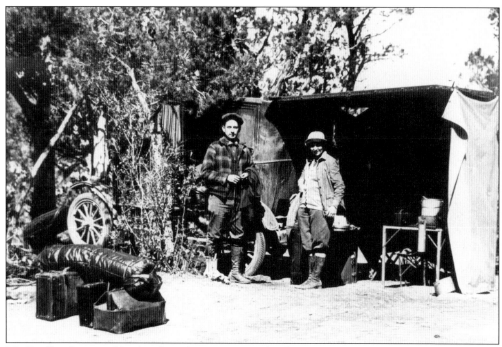

Mr. Dudley Scott and his lovely wife, Louise, pose by their auto-camping rig in this 1929 photo. An engineer, Dudley designed the auto shelter himself and used it on many trips to the Southwest desert. (Courtesy of the Dudley Scott collection, Grand Canyon National Park, #6823.)

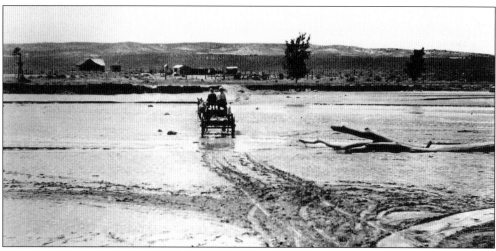

In this 1926 photo, a horse-drawn wagon takes a short cut across a river on its way to the canyon. (Courtesy of the Dudley Scott collection, GCNP #6814.)

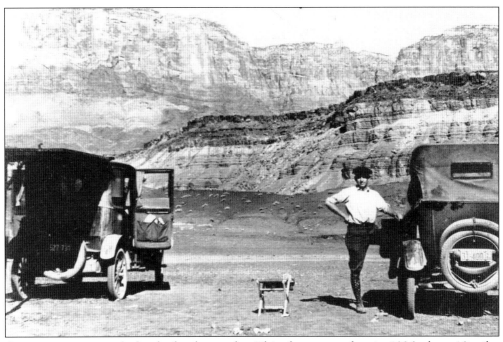

Auto camping was only for the hardy traveler. This photo was taken in 1926, about 10 miles from Lees Ferry. (Courtesy of the Dudley Scott collection, GCNP #6748.)

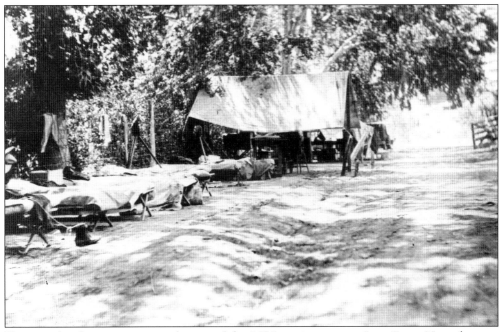

Here are the sleeping accommodations of the 1926 tourist camp at Lees Ferry. Note the tent and open-air beds under the tree. (Courtesy of the Dudley Scott collection, GCNP #6752.)

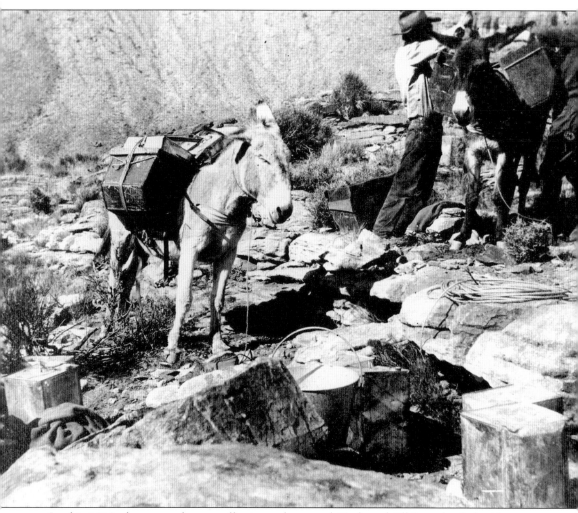

In this 1919 photo, two burros, affectionately named "Jack and Jill," are loaded with survey equipment. Burros were the best method to transport expedition supplies. (GCNP #17420.)

Two

GETTING THERE WAS HALF THE FUN

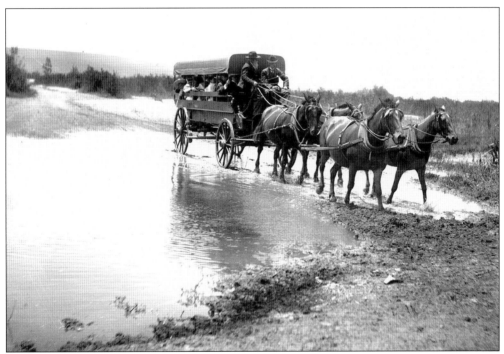

In the early days, reaching the Grand Canyon was difficult. There were no roads from Flagstaff at first, and early travelers had to navigate their way by rough reckoning. There was good grassland between Flagstaff and the canyon, and early settlers established sheep ranches on the range. Many began to homestead in the area. In the mid-1880s, stage and livery companies began to operate out of Flagstaff, Williams, and Ash Fork. There was more interest in the Grand Canyon than ever before. A team of four horses pulls a stagecoach across a shallow stream. Passengers lean out of the open sides of the wagon, c. 1900. (Courtesy of the Colorado Historical Society, #CHS-J1847.)

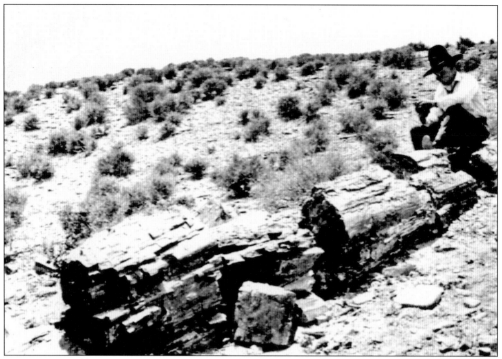

The dry plateau regions today are different from the tree-lined floodplains of 225 million years ago. Many traces of this geological period remain, in the form of petrified wood and other fossils. This petrified log was found in the Petrified Forest National Park in Arizona. (GCNP #17025.)

The arrival of the railroad in Flagstaff in the summer of 1882 opened the area to tourism, allowing travelers a convenient and comfortable way to reach the remote Arizona town by train. These men pose (c. 1913) inside and on top of the Rifle-Meeker stagecoach in Rio Blanco, Colorado. Identified men include Leo Welch, Floyd Austin, and driver Roy Marker. Two teams of horses are harnessed to the stage. (Courtesy of the Colorado Historical Society, #CHS-X6151.)

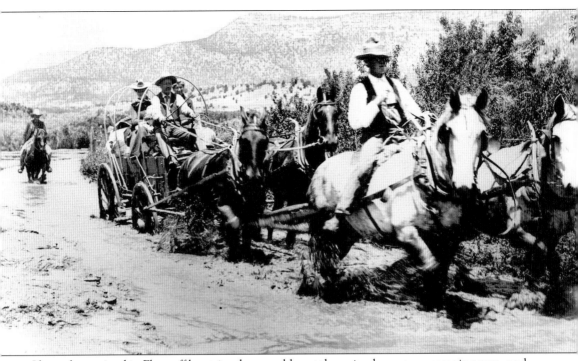

If travelers arrived in Flagstaff by train, they would rent the animals, wagons, camping gear, and guides necessary to make the trip. E. Wolfe and family are in their wagon crossing the Rio Puerco River in New Mexico, on their way to the Grand Canyon in 1902. (GCNP #13677.)

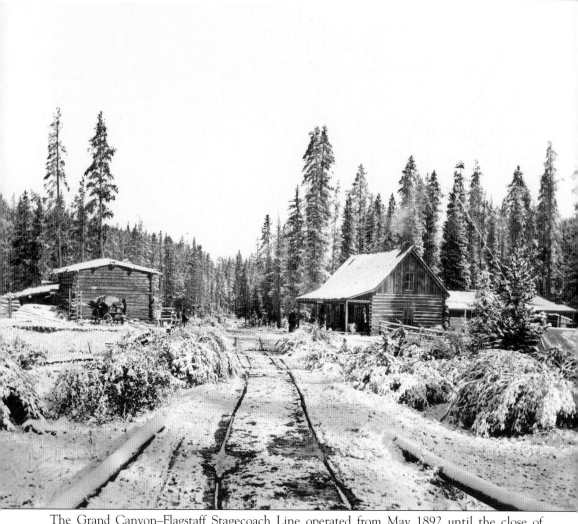

The Grand Canyon–Flagstaff Stagecoach Line operated from May 1892 until the close of tourist season in 1900, a span of nine years. There were other stage lines to the Grand Canyon at the time, running from Williams, Ash Fork, and Peach Springs, but with the support and sponsorship of the railroad, the Flagstaff line was considered the "official" Grand Canyon stage line. This "eating house" provided passengers a rest stop as they changed stages for the Grand Canyon. (Photo by Art Westin, courtesy of the Denver Public Library, Western History Collection, call number X-9499.)

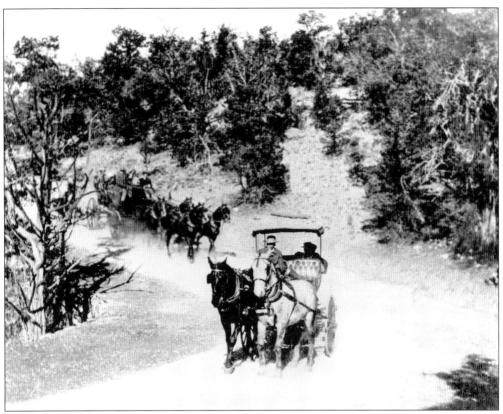

Dated December 5, 1911, this photo shows two horse-drawn coaches carrying Grand Canyon visitors along the newly completed West Rim Drive. (GCNP #9605.)

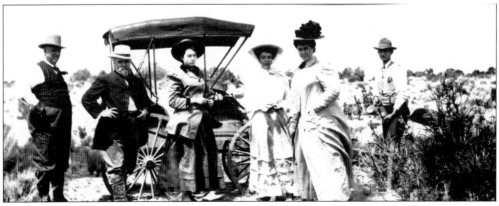

Six people in formal wear stand in front of a carriage coach at the canyon in 1910. (GCNP #15752.)

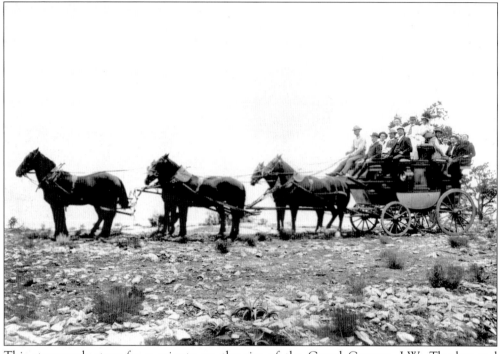

This stagecoach stops for a minute on the rim of the Grand Canyon. J.W. Thurber and passengers take in the view. (GCNP #4886.)

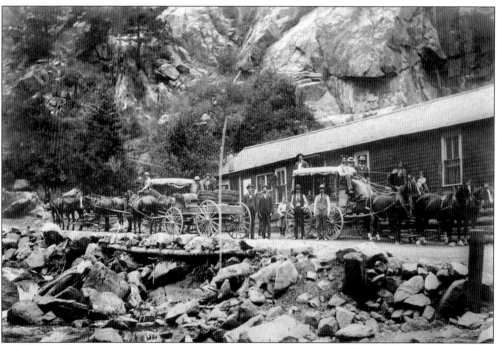

Stagecoaches at Boulder Canyon, a halfway house on the trail to the Grand Canyon. (Photo by Cass, courtesy of the Denver Public Library, Western History Collection, call number X-21850.)

Awe-inspiring scenes like this drew more and more people to the Grand Canyon. To get a sense of the scale, look to the upper right of the photo and find the man precariously perched on a ledge to take a photograph of his own. (GCNP #12406.)

There was good grassland between Flagstaff and the canyon and early settlers established ranches on the range. (Photo by L.C. McClure, courtesy of the Denver Public Library, Western History Collection, call number MCC-2935.)

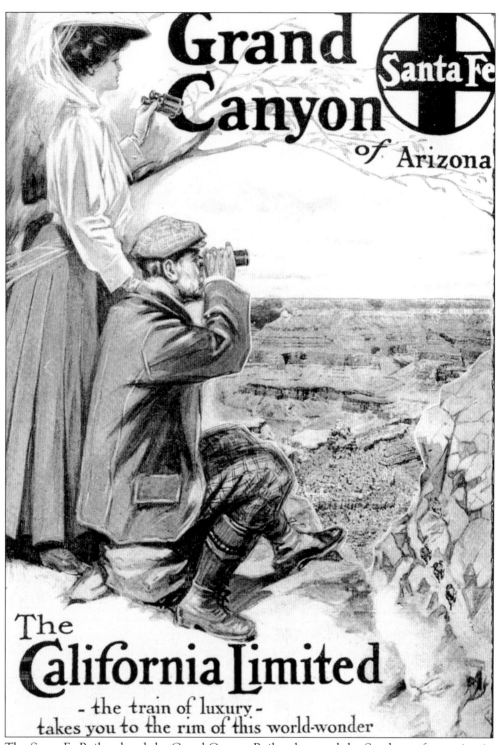

The Santa Fe Railroad and the Grand Canyon Railroad opened the Southwest for tourism in the early 1900s. This *Santa Fe Railroad* magazine ad states: "The California Limited—the train of luxury—takes you to the rim of this world-wonder." (GCNP #9508.)

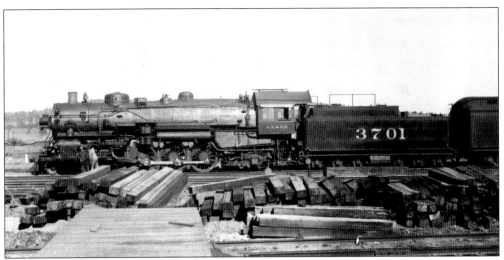

This photo shows an Atchison, Topeka & Santa Fe (AT&SF) Engine 3701 in the rail yard at Williams, Arizona. Tourists could board the Grand Canyon Railroad in Williams and travel the 45 miles to Anita Junction. Here, they could board stagecoaches for the remaining 20-mile trip to the canyon. Travel time was said to be five and a half hours. (Courtesy of the Cline Library, Northern Arizona University.)

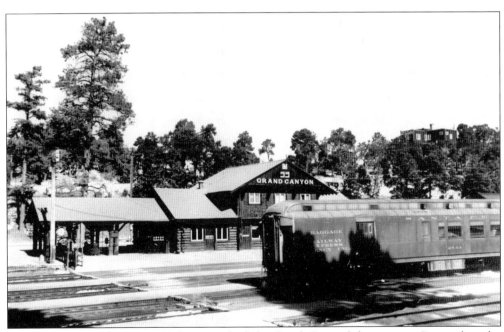

In 1901 the Grand Canyon Railway reached the South Rim of the canyon. Pictured at the depot is a more modern engine (c. 1940) of the AT&SF Railroad, with express baggage car. Verkamps Curio Store can be seen in the background. (GCNP #9465.)

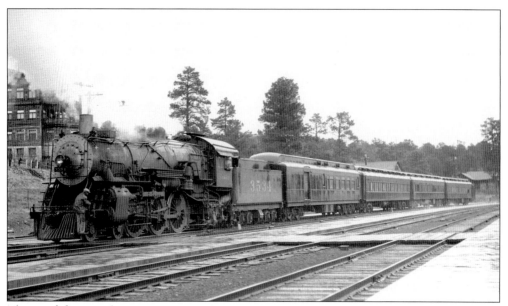

The need for an adequate water supply was a major concern at the canyon. The shortage was especially critical to steam engines, so water stops were placed along the routes. AT&SF locomotive engine No. 3534 was one train that benefited from these water stops. (Photo by Otto Perry, courtesy of the Denver Public Library, Western History Collection, call number OP-1687.)

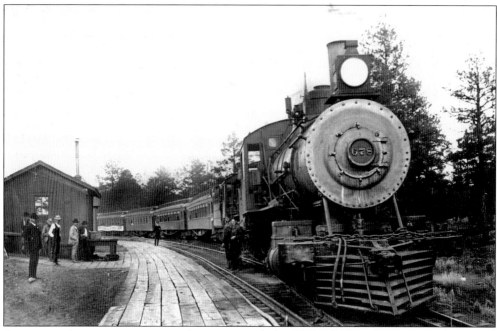

A more modern steam engine with cars, named the "School Train," arrives at the Grand Canyon yard in 1904. To the left, one can see the original depot (with workers on the porch) and boardwalk. (GCNP #5442.)

Fred Harvey made a deal with the Atchison, Topeka & Santa Fe in which the railroad would build and own station hotels and restaurants while he would manage them and provide good food and service for reasonable prices. Harvey insisted on efficient service, making it possible for passengers to eat and be back on the train in 30 minutes. As passengers entered the restaurant, a "drink girl" came with refreshments, and ready to pour coffee, milk, or tea. This timesaving efficiency allowed passengers to enjoy their meals. Here is a picture of the first group of Fred Harvey car-courier guides in uniform, taken in Santa Fe, New Mexico in 1927. (GCNP #1694A.)

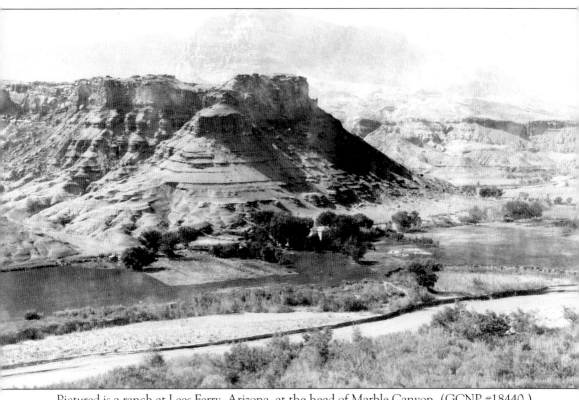

Pictured is a ranch at Lees Ferry, Arizona, at the head of Marble Canyon. (GCNP #18440.)

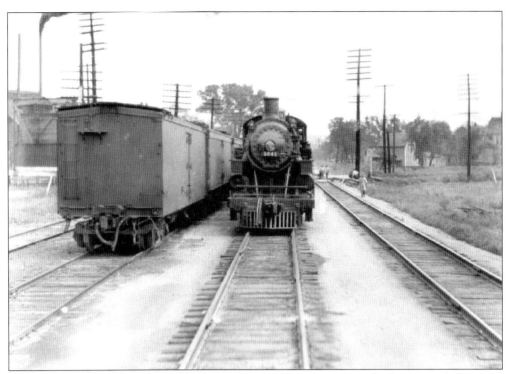

Due in large measure to the railroad, passengers and provisions made their way daily to the canyon, c. 1925. (Courtesy of the Dudley Scott collection.)

Today, an engine bearing the Grand Canyon logo still makes its way to deliver a trainload of tourists, as was done a century ago. (Courtesy of the late Edward Aschoff.)

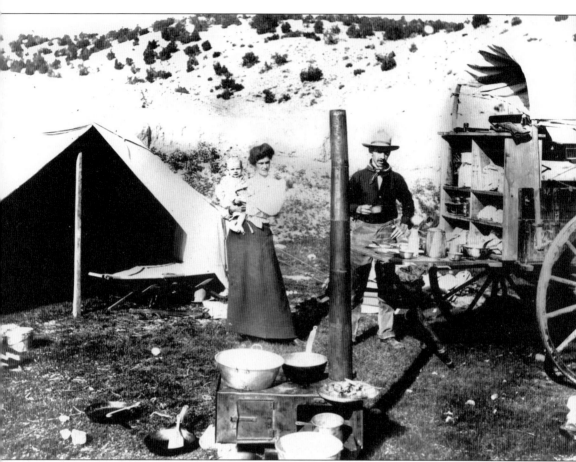

As a new century dawned and transportation improved, Americans were changing how they viewed this country. The United States government promoted the West as a land of abundant resources waiting to be explored, and the discovery of zinc, copper, lead, and asbestos in the Grand Canyon in the 1870s and 1880s led many miners to stake claims there. Here, E. Wolfe and family wagon-camp on the way to the Grand Canyon in 1902. (GCNP #13678.)

Three
GRAND CANYON PIONEERS IN TOURISM

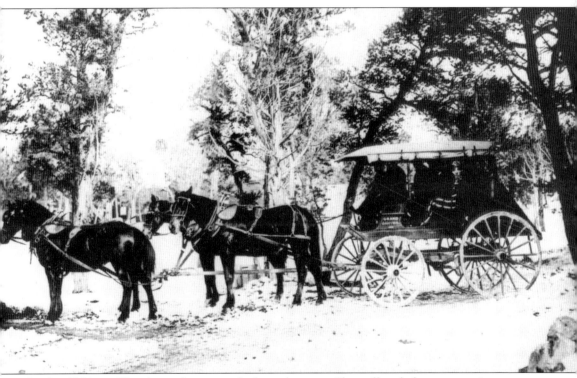

In the 1880s, a 73-mile road was roughed out between Flagstaff and the canyon rim near Grandview Point. The trip took between 10 and 12 hours with three relay stations providing stops, meals, and fresh teams. A resident of Flagstaff, James W. Thurber, was one of the men who offered transportation services. Pictured is Jim Thurber's Grand Canyon Stage, loaded with visitors in 1902. (GCNP #9098.)

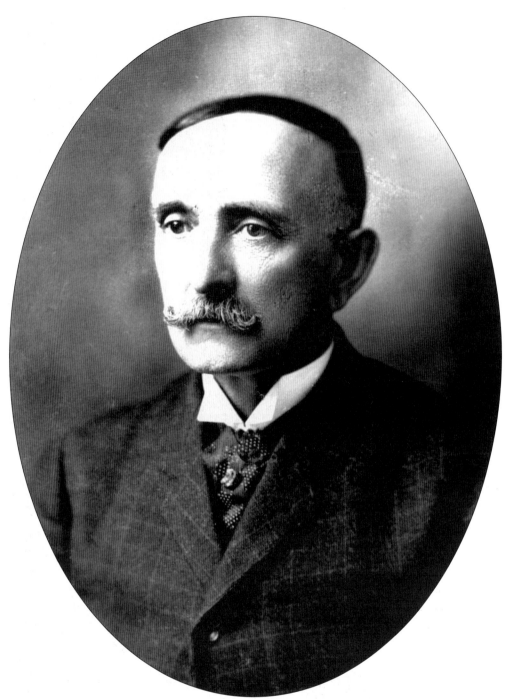

William Wallace Bass arrived at the Grand Canyon in 1882 at the age of 34. During the next 41 years, he built roads, trails, and camps adequate for his prospecting trips and his economic exploration into tourism. He developed a close relationship with the Havasupai Indians and had an abiding love for the canyon. (Courtesy of the Cline Library, Northern Arizona University.)

By 1891, Bass offered tourist trips from Williams to his rim-side camp, and then on to the nearly 2,000 vertical feet below Bass Camp. In 1895, Bill married Ada Lenore Diefendorf, an educated woman who became a full partner in her husband's enterprises. Pictured are Ada Bass and baby Edith. (Courtesy of the Cline Library, Northern Arizona University.)

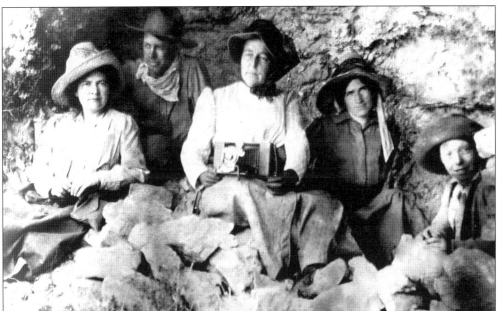

Although Bill Bass actively campaigned for a railroad to run from Williams to the South Rim, its final destination was several miles from his rim-side camp. He had to work hard to retain customers. Ultimately, he had an arrangement with the railroad to make a stop at milepost 59, so visitors could transfer to coaches to take them to Bass Camp. Here, five guests of W.W. Bass pose near Bass camp, c. 1900. The woman in the center is holding a roll-film camera. (GCNP #17794.)

Herbert Lauzon, a Grand Canyon pioneer and mining agent who worked for Bill Bass, married Bill's daughter, Edith. Herbert accompanied the Kolb brothers on the second half of their 1911 river trip. On the rim in 1915, Bert Lauzon is shown with a livery rig that ran between the El Tovar Hotel and Verkamp's Curio Store. (Courtesy of the Cline Library, Northern Arizona University.)

Bill Bass is pictured at the wheel of a 1914 Model Pierce Arrow automobile, which he drove for the Fred Harvey Company. (Courtesy of the Cline Library, Northern Arizona University.)

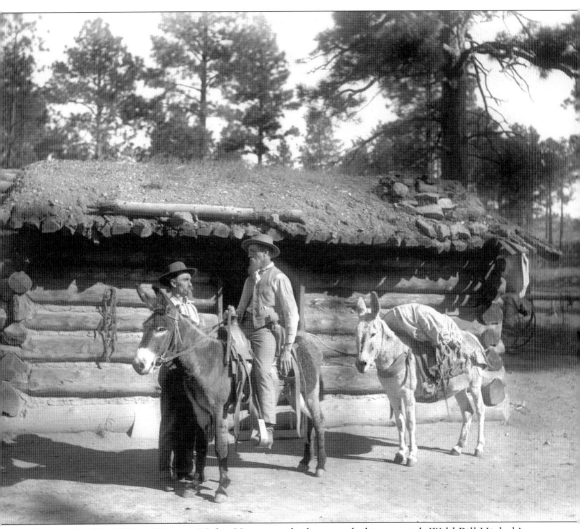

During the Civil War, "Captain" John Hance worked as a muleskinner with Wild Bill Hickok's brother Lorenzo. However, he never really belonged to either side during the fighting. Hance first visited the Grand Canyon in 1881, and by 1883 had moved to the Southeast Rim, three miles east of Grandview Point. He soon improved an inner-canyon trail to facilitate his prospecting. Soon, he noticed the increase of visitors to the canyon and realized that more money could be made in tourism. Pictured here with beards and hats are Hance and a man identified as "Bongere." This log cabin in the Grand Canyon National Park had a dirt and sod roof. The man on the burro wears a scarf and a holster with a pistol. One of the burros has a canvas bag on its back. (Courtesy of the Colorado Historical Society, #CHS-J2998.)

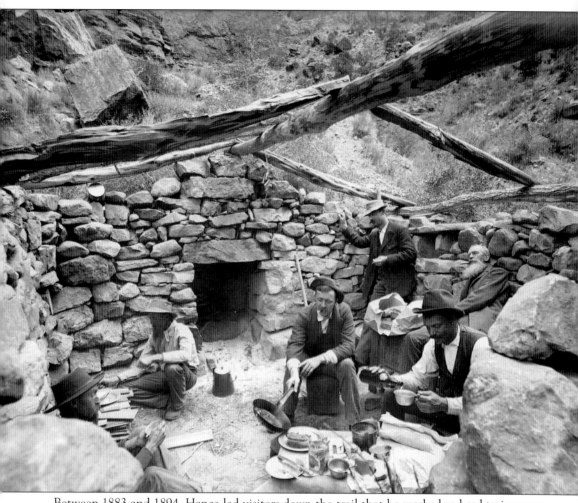

Between 1883 and 1894, Hance led visitors down the trail that he worked so hard to improve. Here, men sit and eat inside the ruins of Hance's cabin and ranch at the foot of Hance Trail in the Grand Canyon. One man holds a frying pan over a fire, and another pours from a bottle into a tin cup. Cans, plates, cups, and a coffee pot are on the ground. A man leans on a dry-laid stone wall near the open roof beams. (Courtesy of the Colorado Historical Society, #CHS-J3023.)

The Sheriff's Office" was a little shack in the back woods built by the children who lived at the Grand Canyon. They used it as a hideout and a clubhouse. (Courtesy of the Cline Library, Northern Arizona University.)

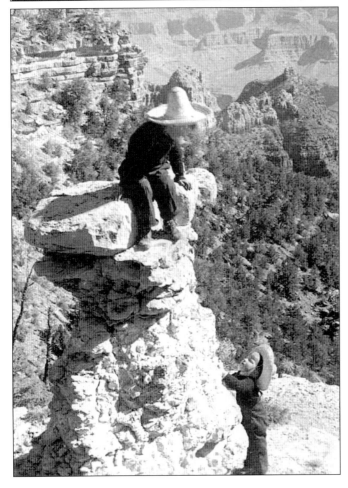

Young mountaineers enjoy a dangerous playground. (Photo by Underwood & Underwood, courtesy of the Denver Public Library, Western History Collection, call number Z-2444.)

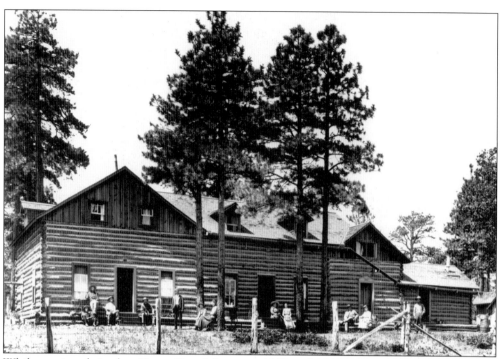

While tourism thrived at Hance Ranch between 1883 and 1907, separate developments took place three miles west at Grandview Point. "Pete" Berry, also a prospector, began to focus on sightseers at the turn of the century. Unlike Hance, his building resembled a hotel. Photographed in 1905, this is the main building of the Grand View Hotel, with guests milling around. The yard was fenced in. (GCNP #12091.)

Grand View Hotel

DAILY STAGE From End of the Santa Fe and Grand Canyon Railroad Track to the Hotel	THE ONLY FIRST-CLASS HOTEL AT THE *Grand Canyon of the Colorado* *River in Arizona* **P. D. BERRY** Manager Grand View Hotel and Stage Line
Season Opened March 15, 1901	WILLIAMS, ARIZON.

Pete Berry built the Grand View Hotel to take advantage of the growing number of vacationers at the canyon. In 1897 he completed work on the hotel. As can be seen on this business card of the Grand View Hotel, it claims to be the only "First Class Hotel" on the rim. Passengers took the daily stage from the end of the Santa Fe & Grand Canyon Railroad to the Hotel. (GCNP #14073.)

44

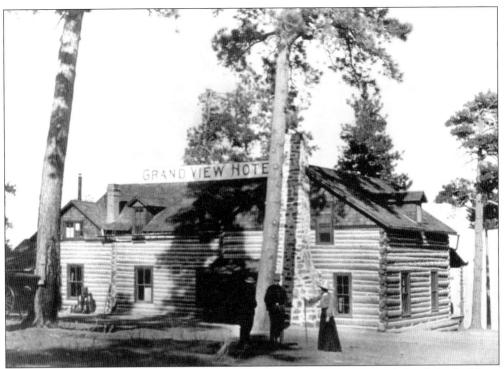

In this *c.* 1900 view of the front of the Grand View Hotel, the canyon is behind the building. The coach is off to the left. The Grand View was the best-decorated and roomiest hotel from 1897 until opening of El Tovar in 1905. (GCNP #6255.)

Visitors to Berry's establishment increased in numbers and enjoyed fair accommodations and spectacular views for $2 per day. This is a *c.* 1900 view from the rim side of the Grand View. A fence encloses the grounds with the tall ponderosa pines. (GCNP #9048.)

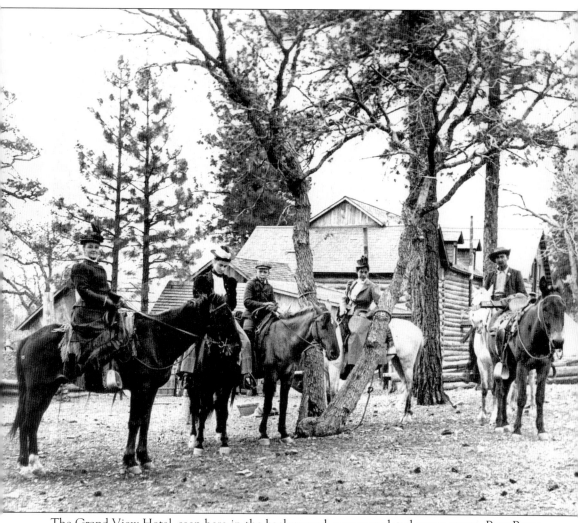

The Grand View Hotel, seen here in the background, accommodated many guests. Pete Berry, at right, was manager of the Grand View for many years. In this 1902 photo taken by Henry C. Peabody, Berry is about to lead this party of four down one of the canyon trails. (GCNP #826.)

In May 1928, construction was completed on the North rim's Grand Canyon Lodge. Similar to buildings on the South Rim, it was a rustic lodge of native stone and ponderosa pine, with an oversized central lobby, dining hall, and recreation room. (GCNP #1364B.)

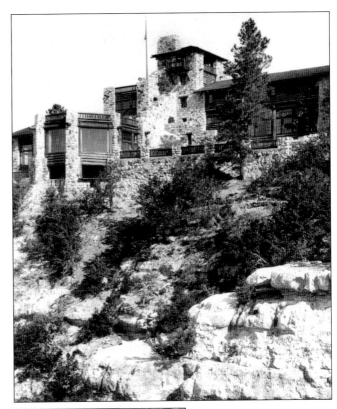

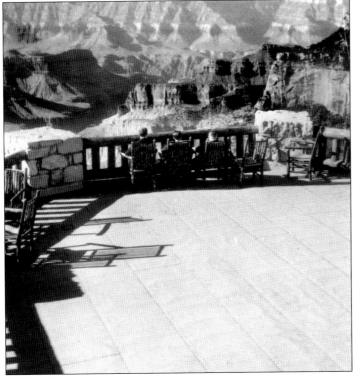

The view from the upper veranda of the Grand Canyon Lodge was absolutely breathtaking. Its south face at the canyon's edge consisted of a glass-enclosed lounge and exterior terraces with an observation tower. (GCNP #13644.)

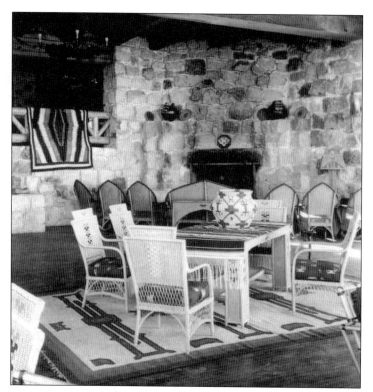

Guests stayed in 120 individual one- and two-bedroom cottages of harmonious log and stone, extending north from two exterior wings. Pictured is the dining room of the Grand Canyon Lodge. (GCNP #13637.)

Pete Berry soon partnered with three brothers: Ralph, Niles, and Burton Cameron. They continued to improve trails for their mining and tourism purposes. Ralph Cameron held many mining claims at the Grand Canyon and struggled for years to compete with the wealth and influence of the railroad. He and his brothers built the Bright Angel Trail in 1891 over an old Havasupai trail, primarily to get to the copper mines in the canyon. He owned and operated the Cameron Hotel and Post Office, pictured here in 1905. (GCNP #14012.)

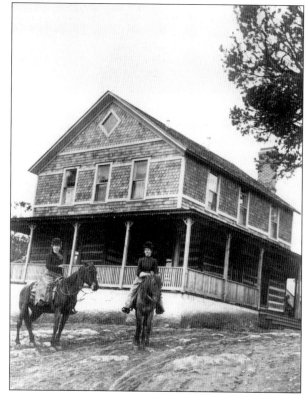

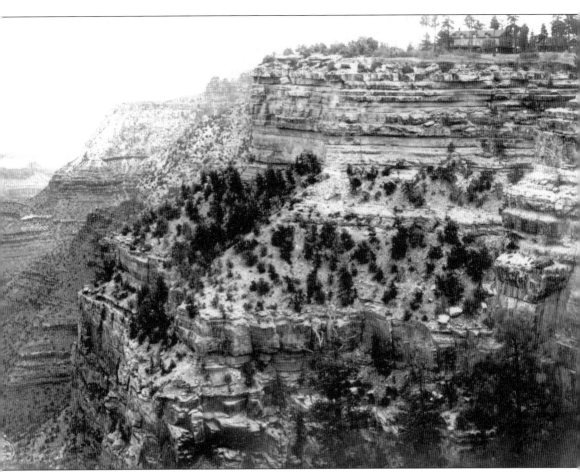

Seen here in 1907 is a distant view of the Grand View Hotel on the rim of the canyon. With the increased presence of the railroad, the Grand View Hotel could not continue to compete. In 1913, Berry sold the hotel to William Randolph Hearst, who closed it that same year. The original Grand View Hotel was torn down in 1929, and later, some of its logs were donated to Mary Colter's Desert View Watchtower project. (GCNP #9839.)

Emery and Ellsworth Kolb built their photographic studio on a Ralph Cameron mining claim at the head of Bright Angel Trail. It operated from 1903 until Emery's death in 1976. The entire time, they photographed mule parties headed down the trail into the canyon on a daily basis. Here, the Kolb brothers pose with Bert Lauzon at Peach Springs. (Courtesy of the Cline Library, Northern Arizona University.)

On September 29, 1909, Emery Kolb captured this photograph of a mule party as it descends Bright Angel Trail. Water for film processing was always a problem. At first, the brothers hauled clear spring water up from Indian Gardens. Later, they built a processing cabin and carried the film down to Indian Gardens to have it developed. (GCNP #18165.)

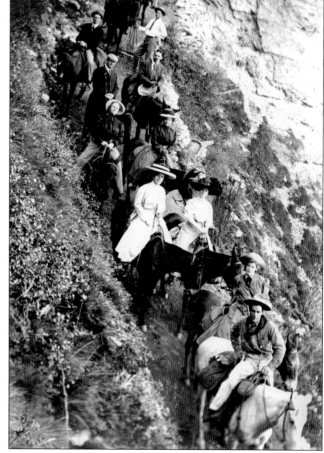

The Kolb brothers epitomized the adventurous spirit of the early Grand Canyon pioneers. They decided to risk their entire holdings to fund an expedition to produce a pictorial record of the canyons along the Green River to the Colorado River, a distance of 1,200 miles. In this 1902 photo, Ellsworth Kolb poses with Jim Lane, a trail guide at the Grand Canyon. (GCNP #9090.)

To supplement their income from the mule photos, the Kolbs searched the canyon to document its beautiful views. They later colored their images by hand and sold them in bound albums at the studio. Pictured is Kolb Studio, preserved as an historic landmark and still in operation today on the South Rim. (Courtesy of the late Edward Aschoff.)

Emery Kolb remained active at his studio until his death in 1976 at age 95. He and his brother Ellsworth took tens of thousands of photographs that capture the rich history of the Grand Canyon. Pictured is Emery Kolb in his studio at the Grand Canyon. (Courtesy of the Cline Library, Northern Arizona University.)

What appears at first glance to be simply a large tent is, in fact, a curio store. John George Verkamp stands proudly in front of his place of business here on the grounds of Bright Angel Camp. John would sell various Native-American crafts and curios to tourists who wanted a souvenir or two to take home. (GCNP #5254.)

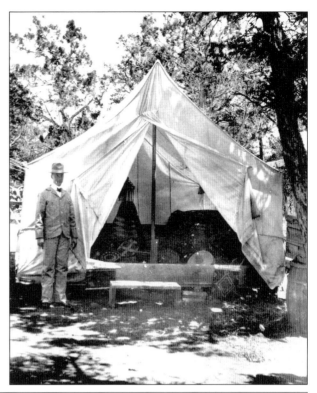

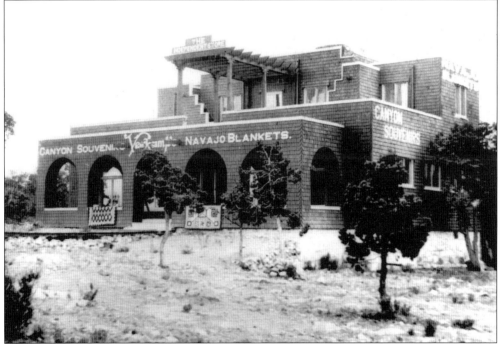

Verkamp built his store in 1905, east of the Hopi House. It continues to be family owned and operated today. This 1910 photograph shows Verkamp's Curios with rugs on display outside, and signs that read: "Canyon souvenirs, Navajo blankets." (GCNP #11365.)

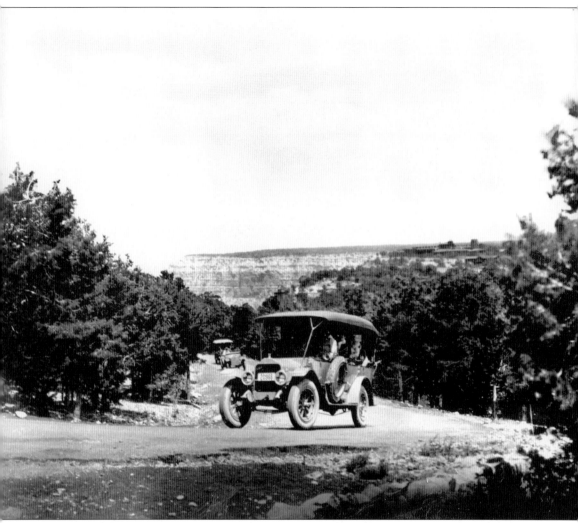

The Fred Harvey Company operated all of the hotels and restaurants along the Santa Fe railroad lines, as well as many dining cars. Here in 1920, a Fred Harvey touring car motors up West Rim Drive with its cargo of tourists. El Tovar is off in the distance. (GCNP #5426.)

Four
MARY COLTER
WOMAN OF VISION

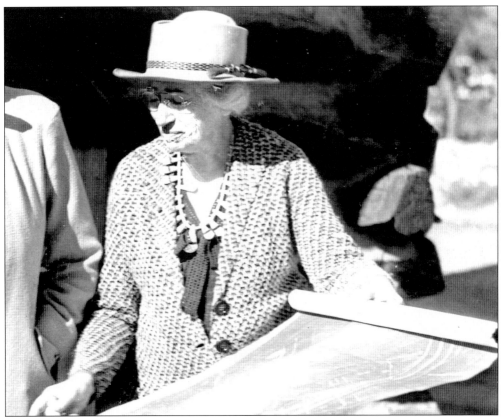

Although she always considered St. Paul her home, Mary Elizabeth Jane Colter was born in Pittsburgh, Pennsylvania. In the 1890s, Mary Colter was a schoolteacher in St. Paul, Minnesota. In 1902, she became an architect, designer, and decorator for the Fred Harvey Company. Her designs were a departure from the traditional American style of architecture, which mainly followed European fashions. Colter's architecture grew out of the land, resembling ancient structures left by the tribes that inhabited the region long before Columbus. In this 1935 photo, Mary holds plans. (GCNP #16942.)

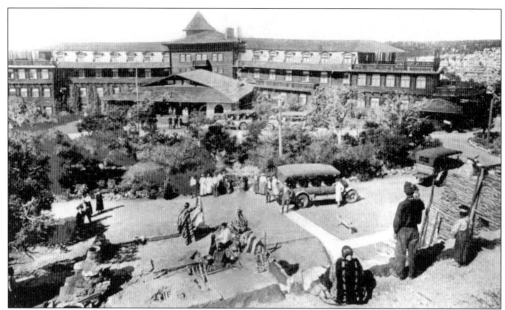

In 1904, the Fred Harvey Company decided to build a hotel at the Grand Canyon to accommodate the increased number of tourists. The company contacted Colter to design a building directly across from El Tovar. She named it the Hopi House, styling it after Native-American structures. The doors opened a few days before the hotel on January 1, 1905. Here is a 1929 view of El Tovar from the roof of the Hopi House. (GCNP #17016.)

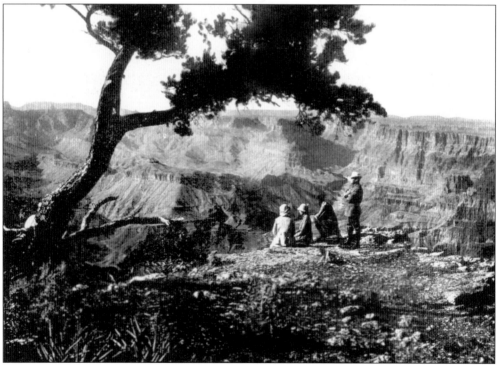

Mary Colter's buildings had their roots in the history of the land. Here, a few tourists take in the vast panorama of the canyon. (GCNP #17024.)

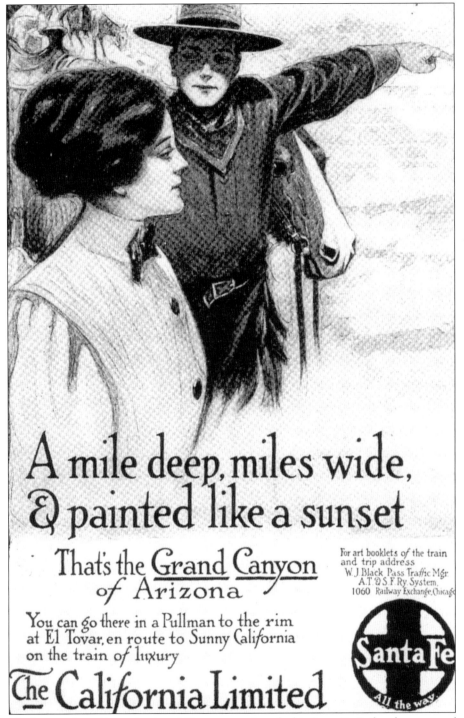

A mile deep, miles wide, & painted like a sunset

That's the <u>Grand Canyon</u> of Arizona

For art booklets of the train and trip address
W.J.Black Pass Traffic Mgr.
A.T.& S.F.Ry.System,
1060 Railway Exchange,Chicago

You can go there in a Pullman to the rim at El Tovar, en route to Sunny California on the train of luxury

The California Limited

Santa Fe
All the way

"A mile deep, miles wide, and painted like a sunset," reads this *Santa Fe Railroad* magazine dated 1910. The Fred Harvey Company realized there were handsome economic possibilities at the Grand Canyon. The company operated gift shops, newsstands, restaurants, and hotels in cooperation with Santa Fe Railroad, as early as 1876. (GCNP #9507.)

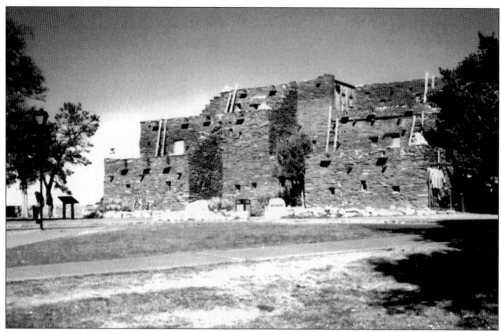

It soon became apparent that visitors would be interested in purchasing Native-American crafts while at the canyon. Typical of Colter's design, the Hopi House was built with materials at hand, creating a dwelling in harmony with nature. (Courtesy of the late Edward Aschoff.)

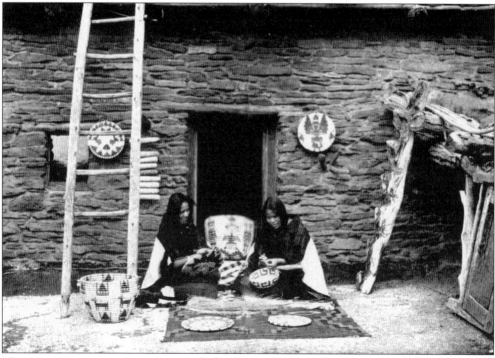

The Hopi House is a re-creation of the Hopi dwellings in Oraibi, Arizona. This 1929 photo shows Hopi basket makers at the Hopi House. (GCNP #17019.)

Visitors to the Grand Canyon were fascinated by the Native-American hand-woven blankets and baskets, rugs, silver jewelry, and pottery. Native-American craft items were sold in various sections of the building. It was Mary Colter's job to make them appealing. Here, Navajo rugs are shown on display in one of the rooms at the Hopi House. (GCNP #16671.)

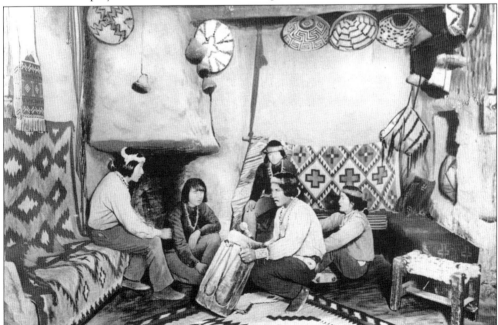

In the evening, the Hopi sang traditional songs and performed their traditional dances, which eventually became a daily event. Photographed in 1905, five native men are shown drumming and singing in the Hopi House retail showroom. (GCNP #9938.)

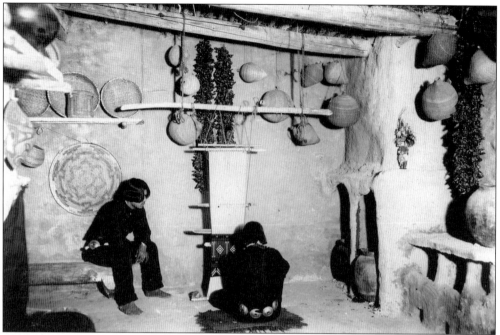

One of the novel aspects of the building was being able to watch firsthand the Native-American artisans at work. In the Hopi House, a craftsman, undisturbed by observers, weaves a wide sash. Weaved baskets are displayed on the walls. (GCNP #9825.)

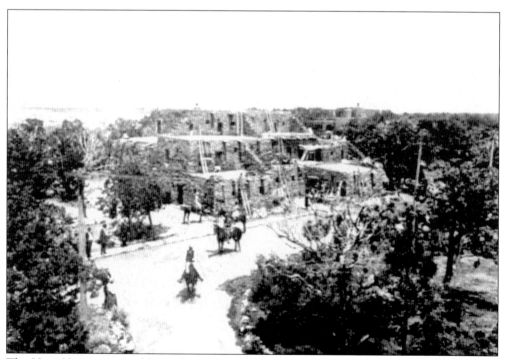

The Hopi House, pictured here, demonstrates Colter's ability to re-create and honor the past while updating the design for modern use. (GCNP #17018.)

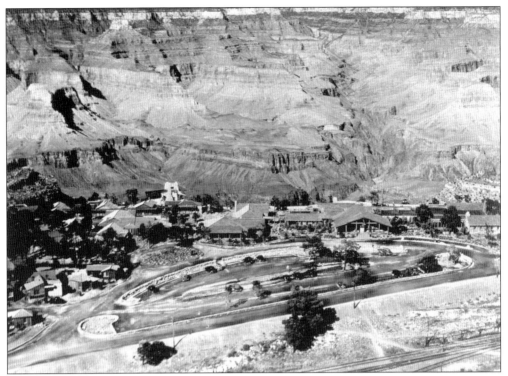

Here is an aerial view of Bright Angel Lodge and the Lookout, two of Mary Colter's designs. The Lookout was patterned after authentic Native-American dwellings, while Bright Angel Lodge captured the style of early pioneer buildings at the Grand Canyon. (GCNP #9538.)

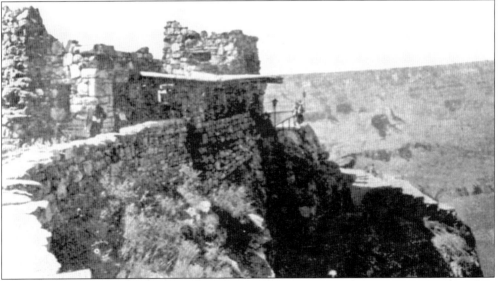

Like other architects in California and the Southwest, Mary Colter was more interested in rediscovering the cultural heritage of the region than imitating European styles. The Lookout, designed after authentic ruins of Native-American towers and dwellings found in the Southwest, was built on a precipice west of El Tovar, near Kolb's Studio. It was intended to be a place where tourists could view and photograph the canyon. (GCNP #17018.)

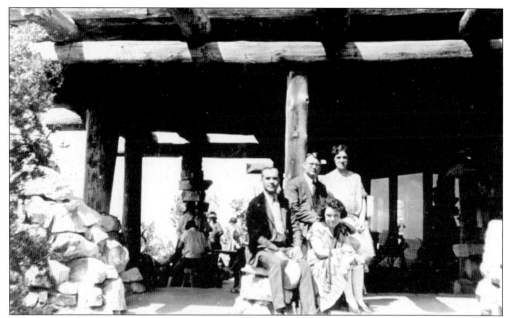

Tourism dramatically increased at the Grand Canyon with the arrival of the railroad, and the Fred Harvey Company soon found it necessary to expand its facilities to accommodate this growth. A terminal was needed at the end of the eight-mile ride along Hermit Rim Road. Mary Colter was hired to design the remarkable Hermit's Rest. In this 1918 photo, a small group gathers on the veranda of Hermit's Rest. (GCNP #177774.)

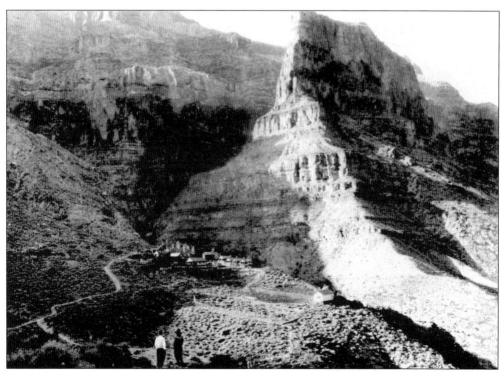

Here is a view of Hermit Cabins with Hermit Peak in the background. (GCNP #176030.)

AT&SF Railroad engineer Sid Terry stands by his engine. Pictured in the background is Colter Hall, the large women's dormitory for Fred Harvey employees, named for Mary Colter. The El Tovar can also be seen. (GCNP #11450.)

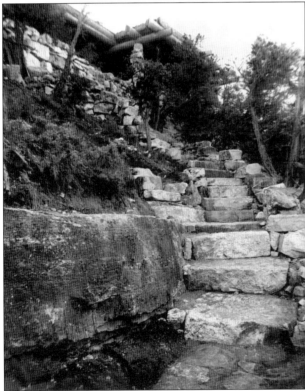

Mary Colter designed Hermit's Rest to look like a dwelling constructed by an untrained mountain man using the natural timber and boulders of the area. From the entrance path, the structure looks like a jumble of stones, with a porch that extended to the very edge of the canyon. Stone steps lead to the ledge below. (GCNP #11432.)

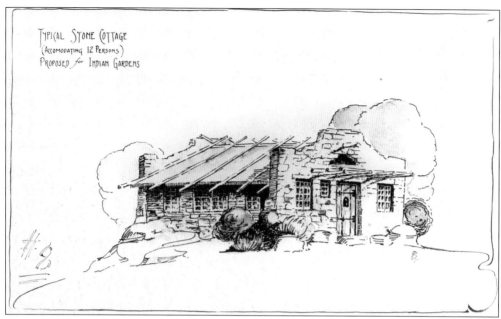

In 1916, Fred Harvey submitted proposals to the Forest Service for building tourist accommodations at Bright Angel Camp and at Indian Gardens, 3,200 feet down the canyon. The buildings at Indian Gardens were never built. Ms. Colter's drawings are the only signed drawings of that proposal. This is one of the proposed Indian Garden cottages, which would have accommodated 12 visitors. (GCNP #16682.)

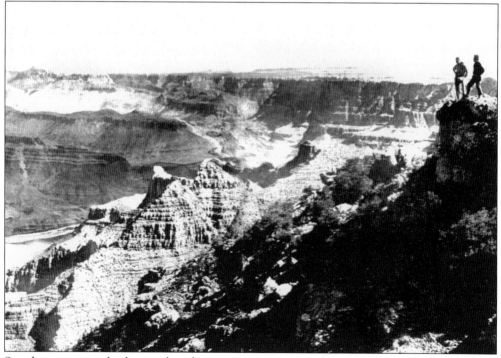

Standing precariously close to the edge, two men are pictured at early morning after a storm at Lipan Point. (GCNP #17023.)

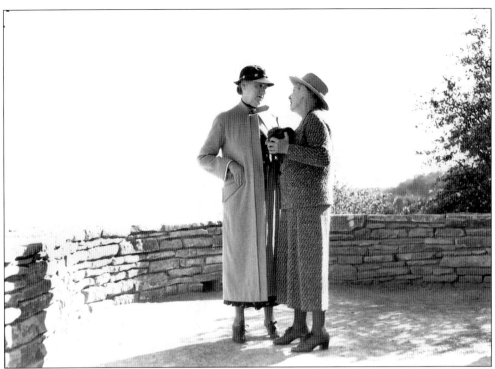

Mary Colter and Mrs. Ickes, wife of the secretary of the interior, are pictured here in 1935, on the rim near El Tovar. Note Ms. Colter's home-movie camera in her hand. (GCNP #16938.)

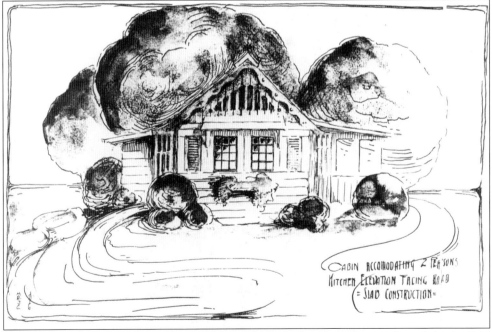

CABIN ACCOMODATING 2 PERSONS
KITCHEN ELEVATION FACING ROAD
= SLAB CONSTRUCTION =

Among the plans for Indian Gardens were some guesthouses. This is Mary Colter's 1916 architectural drawing of a two-person cabin for the proposal. (GCNP #16712.)

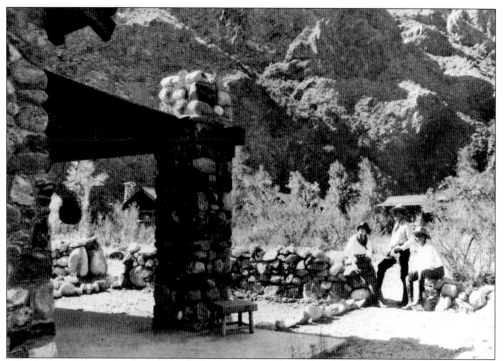

The Fred Harvey Company offered mule trips into the canyon, and the trekkers needed accommodations. Mary Colter drew up plans for Phantom Ranch, named after nearby Phantom Creek. (GCNP #17033.)

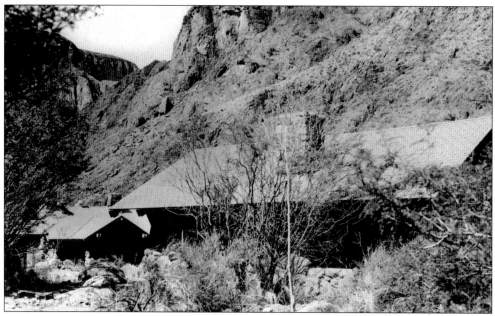

The mule trip down the 5,000-foot descent was made easier when visitors could stay overnight at the ranch and return to the rim the next day. Several of the main buildings at Phantom Ranch are pictured here in 1922 shortly after their construction. (Photo by Mary Colter, GCNP #16956.)

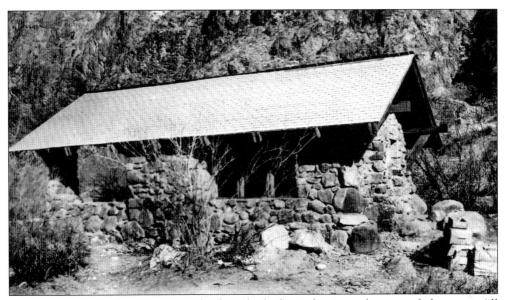

The ranch consisted of a group of cabins built from the natural stone of the area. All other materials had to be brought in by mules. Mary Colter photographed the original Phantom Ranch cabin Number 11, just after construction in 1922. (Photo by Mary Colter, GCNP #16953.)

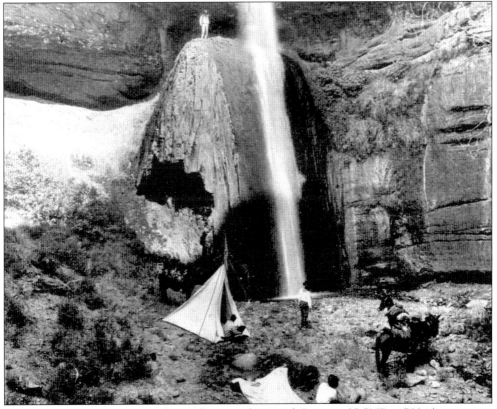

Campers enjoy picturesque Ribbon Falls in Bright Angel Canyon. (GCNP #17034.)

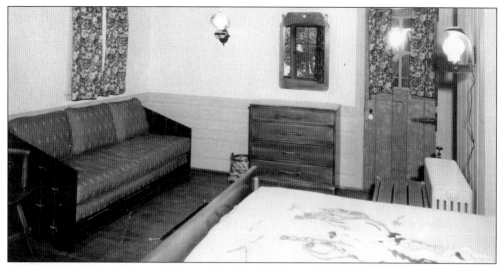

Mary Colter designed Bright Angel Lodge to be more moderately priced than the El Tovar Hotel. It was a pioneer-style building in natural wood tones and had an unobstructed view of the canyon. A true conservationist, Mary Colter was instrumental in saving several historic buildings from being demolished. Among them were the first post office of the Grand Canyon, and a cabin where Buckey O'Neill lived. He was a colorful, early-day sheriff who was one of Teddy Roosevelt's Rough Riders and was killed in Cuba. Both the post office and O'Neill's cabin became part of Bright Angel Lodge. This 1936 photo shows the interior of one of the lodge's rooms as decorated by Mary Colter. Note the cowboy bedspread. (GCNP #16721A.)

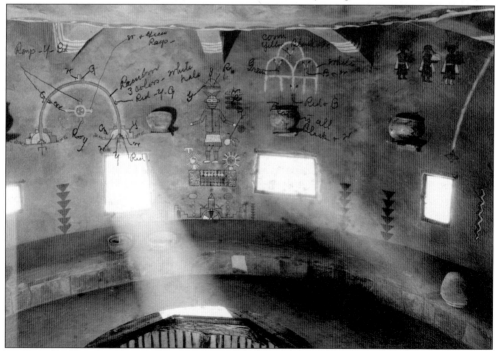

Mary Colter re-created an original Native-American watchtower at Desert View. It was made of natural stone found in the area. Shown in this 1933 photo is a mural in the watchtower. Mary Colter's written notation is superimposed. (GCNP #16957.)

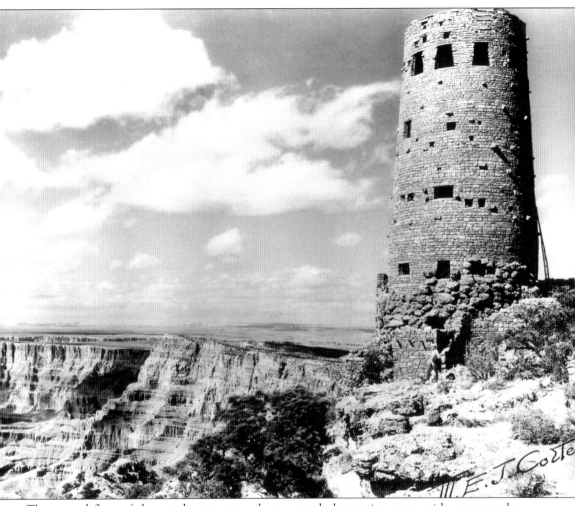

The ground floor of the watchtower was a large, round observation room with a spectacular view of the canyon. The room was modeled after a Native-American kiva, with some additions for the comfort of the visitors. From the kiva, one could ascend to the first floor of the tower, the Hopi Room. The room was decorated with many authentic Hopi paintings, and there were galleries above the Hopi Room. As a historic preservationist, she managed to save some of the logs from the original Grand View Hotel, which was torn down in 1929, and use them in her watchtower project. This is a 1932 photograph of the completed watchtower, signed by Mary Colter. (GCNP #17010b.)

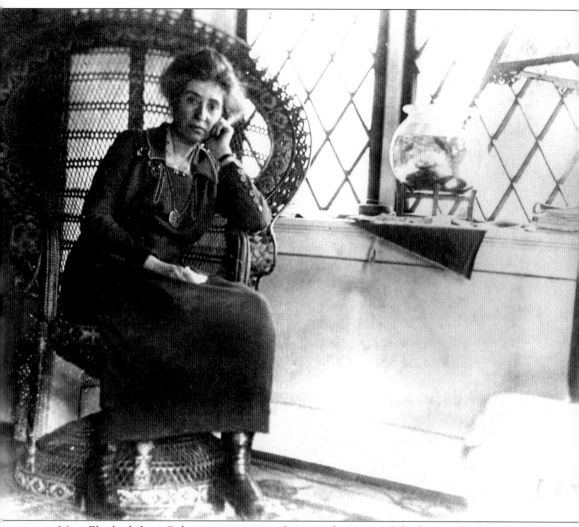

Mary Elizabeth Jane Colter was a woman of vision who accomplished so much in her lifetime. She created a score of impressive buildings throughout the Southwest, and she advanced a new style of architecture that departed from the European tradition. Her designs evolved to match the modernity of the rapidly advancing railroads, while preserving the Native-American and Spanish heritage of the Southwest she loved. In this 1919 photo, Colter, age 50, sits in a rattan chair at the Grand Canyon National Park. (GCNP #16951.)

Five

EL TOVAR

THE CANYON'S CHARM

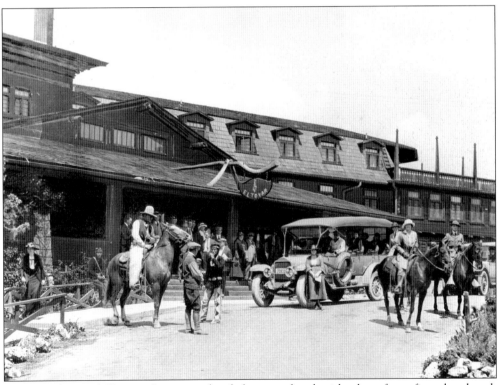

In 1904, the Fred Harvey Company decided to go ahead with plans for a first-class hotel. Charles F. Whittlesey of Chicago was given the assignment. The hotel was named for Don Pedro de Tovar, an explorer with Francisco Vasquez de Coronado in 1540. Tovar is credited as being the first European to learn of the existence of the Grand Canyon. Pictured here in 1920 are a variety of visitors in front of the El Tovar Hotel, horses and touring cars. (GCNP #9654B.)

When completed, El Tovar was a huge, 100-room, dark wooden structure with a Norwegian (or Swiss) chalet design. This is the front entrance to the El Tovar, pictured in 1905. Note the dirt drive and wagon-wheel tracks. (GCNP #9449.)

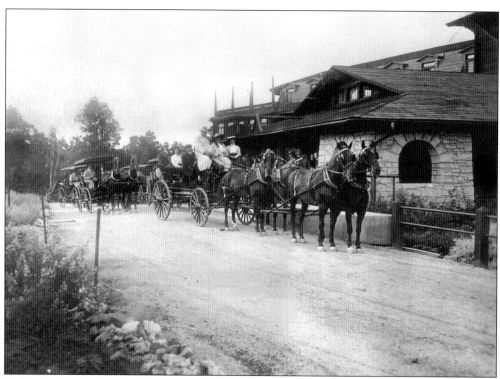

Early coaching parties leave El Tovar Hotel. Later a boardwalk would be added. This particular photo was taken in 1905. (GCNP #9851B.)

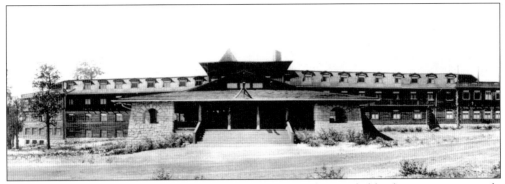

El Tovar cost $250,000 to build and was once referenced as probably the most expensively constructed log house in America. Most of the logs were Douglas firs brought in from Oregon by train. The hotel soon became a mecca for travelers from all over the world. Pictured is a frontal view of the El Tovar Hotel in 1904, just after construction. (GCNP #9835.)

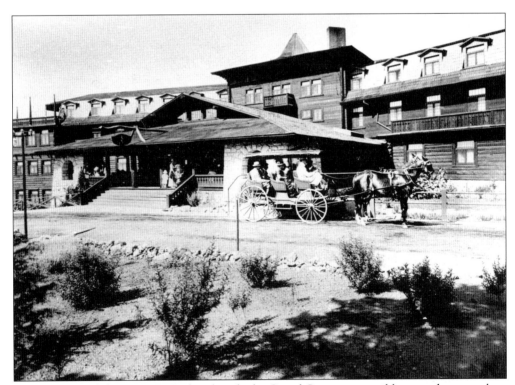

Fred Harvey and the Santa Fe Railroad made the Grand Canyon accessible to modern travelers. Stages delivered passengers from the depot to the El Tovar Hotel. In this 1908 photo, a two-horse carriage stands ready for its trip, loaded with passengers just to the right of the entrance to El Tovar. Other visitors wait on the porch. (GCNP #15523.)

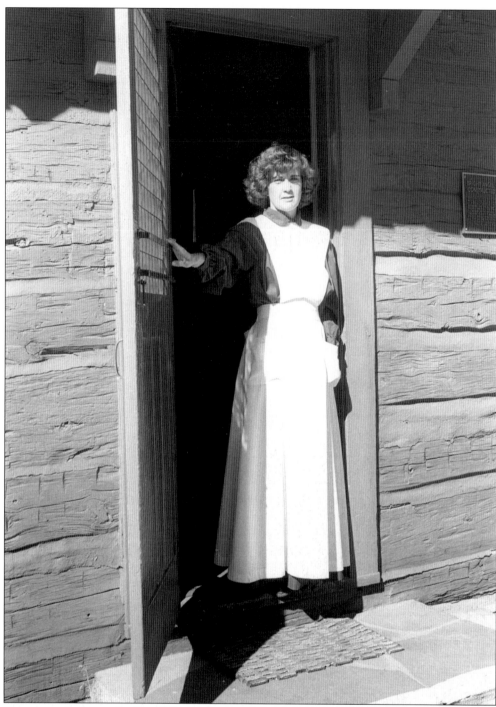

Harvey employees at the Grand Canyon became a community unto themselves. There were few women working with any railroad in the Southwest. As the Fred Harvey Company grew, the need for waitresses and salesgirls became evident. The Harvey girls were usually single women, between the ages of 18 and 30, who wanted to experience the adventure of the vast lands west of the Mississippi. Here, a girl poses in a 1910 Harvey Girl uniform. (GCNP #6246.)

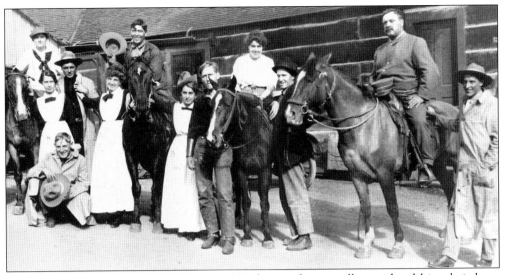

Even after the death of Fred Harvey in 1901, his employees still considered him their boss. Thirteen employees nicknamed the "Fred Harvey Bunch" pose in front of the Bright Angel Hotel in 1915. (GCNP #18207.)

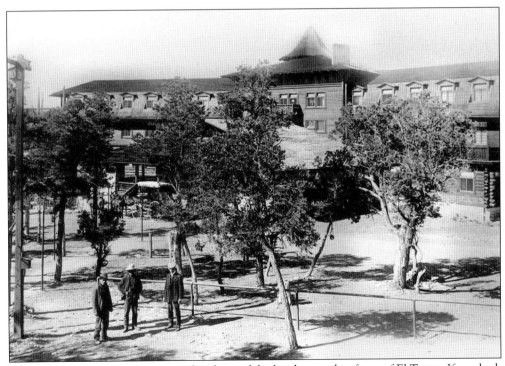

In this 1912 photo, three men stand in front of the hitching rail in front of El Tovar. If you look carefully between the trees behind them, you will see a typical horse-drawn carriage of the day. (GCNP #9536.)

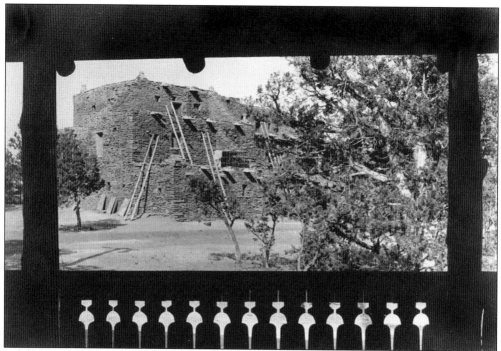

This 1906 view from the porch of El Tovar shows the Hopi House and the Swiss-chalet style of architecture throughout. (GCNP #9516.)

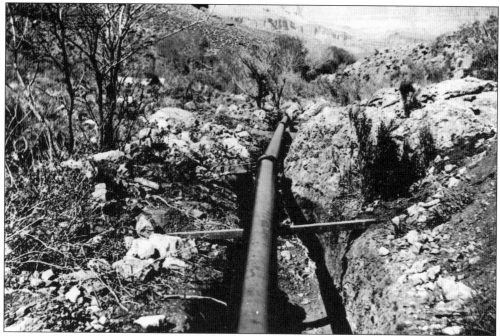

Lack of water was always a major problem at the canyon. Before the pipeline, it had to be hauled daily in railroad tanker cars from Del Rio, a distance of some 120 miles. In this 1931 photo, a water pipeline, having left Indian Gardens, starts its climb to the South Rim. (GCNP #16976.)

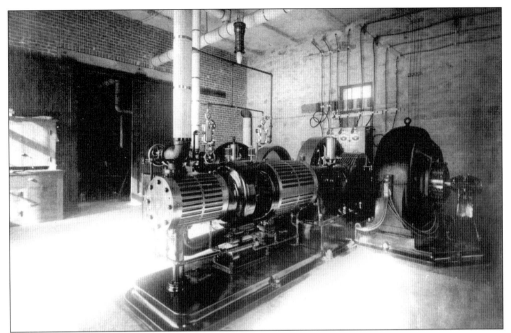

Refrigerated boxcars made it possible to bring the best grade of meat from Kansas City and fruits and vegetables from California. The hotel had electric lights with power provided by a steam generator. Here is a 1905 photo of the interior of the first powerhouse and electric plant at the El Tovar Hotel. (GCNP #9464.)

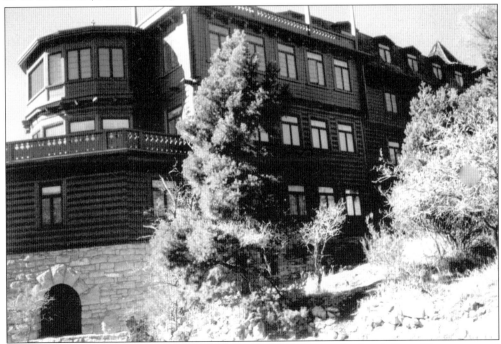

The opening of El Tovar doubled the number of guestrooms at the South Rim. The exterior of the hotel reflects a combination style and heritage, depicting part Victorian resort and part rustic log cabin. (Courtesy of the late Edward Aschoff.)

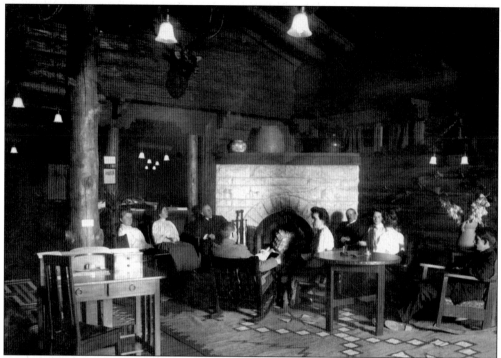

El Tovar featured a solarium, music room, clubroom, amusement room, and a roof garden. The lobby was decorated with hunting trophies and Native-American pottery. El Tovar guests, such as those pictured here, often sat in the Rendezvous Room around the main fireplace. Note the striking pattern of the eye-catching rug. (GCNP #9852.)

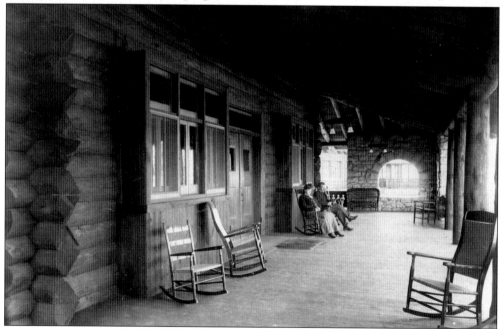

In this 1905 photo, two guests relax in rocking chairs as they take in the view from the east porch and main entrance to El Tovar. (GCNP #9841.)

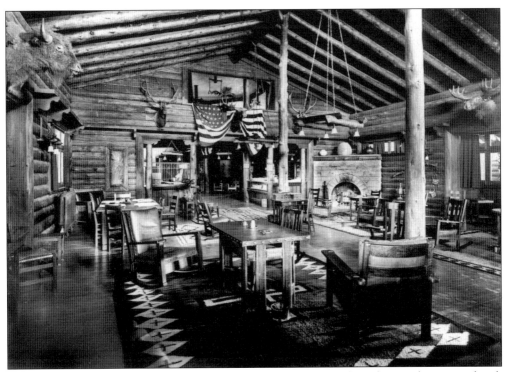
The interior of the rendezvous room, with the American flag draped around a moose head, also featured the original arts and crafts of area tribes. (GCNP #13658.)

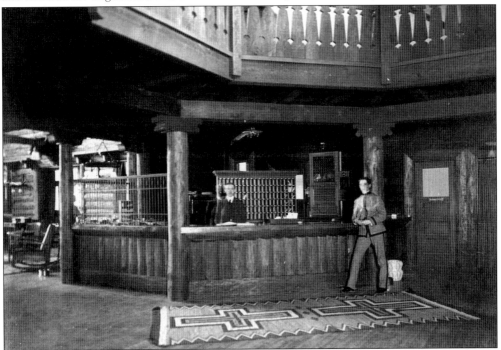
This 1905 photo shows the rotunda, a front desk office area in the center of the building with the switchboard, desk clerk, and bellman. (GCNP #9453.)

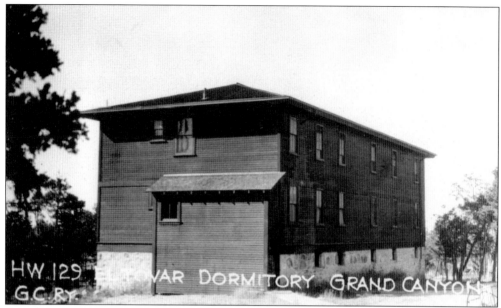

In order to serve the large number of visitors, the Fred Harvey Company had to maintain a fairly large staff. To accommodate them, separate dormitories for men and women were built near the hotel. This picture is dated April 8, 1915. (GCNP #11982.)

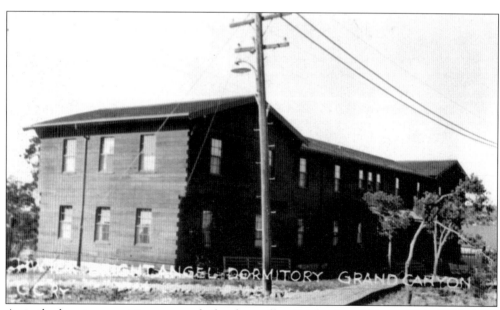

A similar housing provision was made for the staff at Bright Angel Camp. This 1915 photo shows the men's dormitory for camp service workers. (GCNP #11985.)

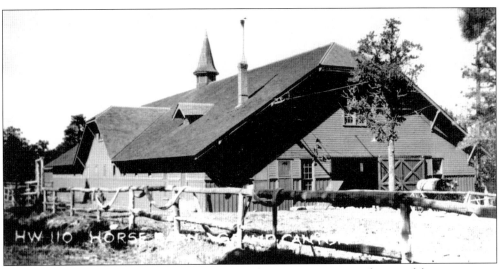

In this 1915 photo of a Fred Harvey horse barn, you can see the careful attention to architectural details such as the tall cupola and dormer on the roof. (GCNP #11983.)

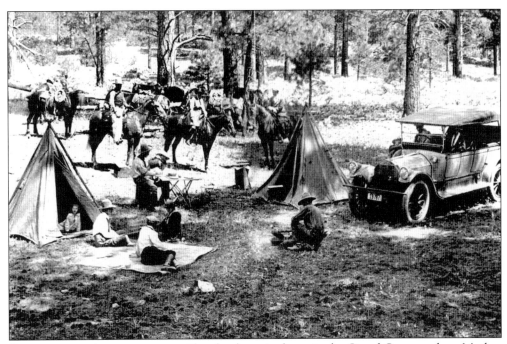

Communing with nature was considered to be at its finest in the Grand Canyon where Mother Nature wrote large her most majestic signature. Here, whole families could camp out in the pines and grasp firsthand vistas that no book could capture. Note the young child in the tent to the left. (GCNP #17038.)

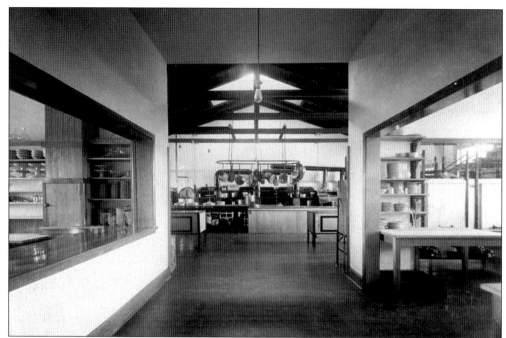

To provide the best quality food for its dining rooms, the hotel had its own greenhouse in which to raise vegetables, a herd of cows to produce milk, and chickens for both fresh eggs and poultry. Shown is an overview of the kitchen at El Tovar as it was in 1905, with a pantry on the left, ranges in the center, and a washer on the right. Note the large array of pots and pans hanging in the center, awaiting the next meal's use. (GCNP #9450.)

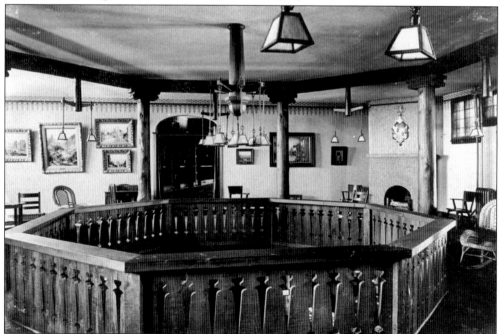

The rotunda over the office featured the mezzanine and the ladies' lounge, where the ladies could pleasantly pass the time away. (GCNP #9452.)

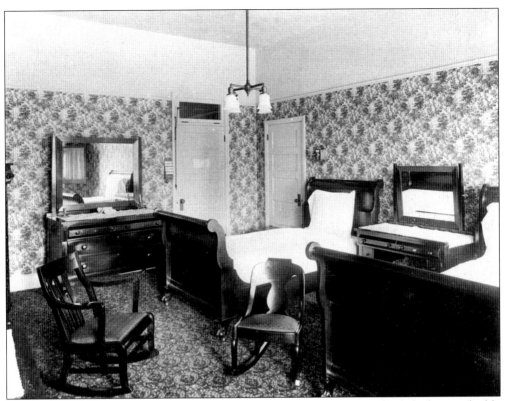

This 1905 photo shows a typical bedroom at El Tovar, featuring two sleigh beds: one double and one single. The double is to the right where we see only a portion of the footboard. (GCNP #9457.)

On the rim of El Tovar, these men gather to enjoy some welcome the Western sunshine. Note the quite formal attire. (Courtesy of the Cline Library, Northern Arizona University.)

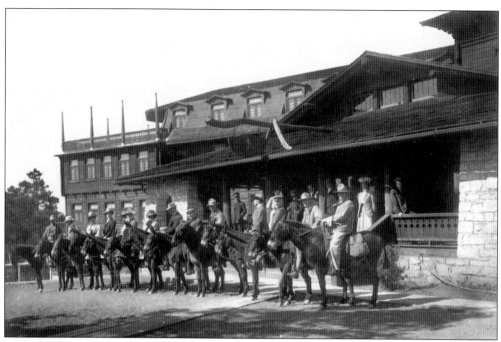

From 1903 to 1924, Bright Angel Trail was operated by Ralph Cameron. Travelers were required to pay a toll prior to beginning their descent. A Bright Angel Trail party poses in front of El Tovar Hotel before setting out on their adventure. (GCNP #11337.)

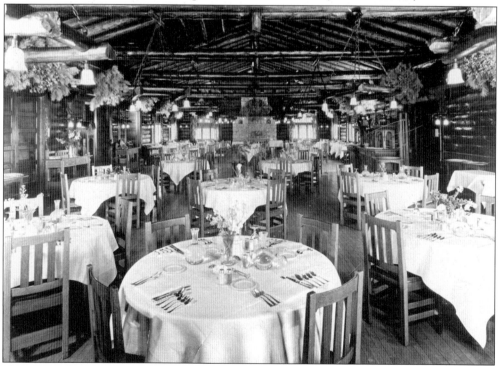

This 1935 photo of the interior of the El Tovar dining room shows all is in order for the guests, including decorations of richly scented pine-bough garlands. (GCNP #9657.)

Since El Tovar was located near the head of Bright Angel Trail, guests were able to visit the barn, and saddle horses. Pictured here is the corral at El Tovar Hotel. (Photo by L.C. McClure, courtesy of the Denver Public Library, Western History Collection, call number MCC-1194.)

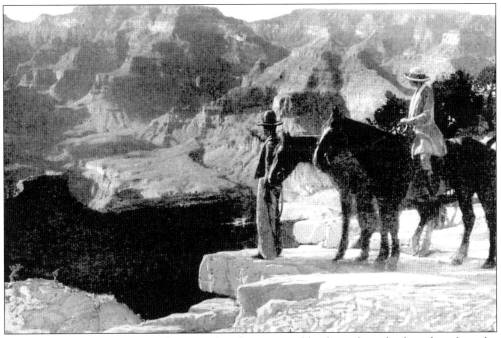

In addition to trail parties to the river, hotel guests could ride on horseback and explore the pine forests and the many bridle paths along the rim. In this 1929 photo, riders look out at Grandeur Point. (GCNP #17017.)

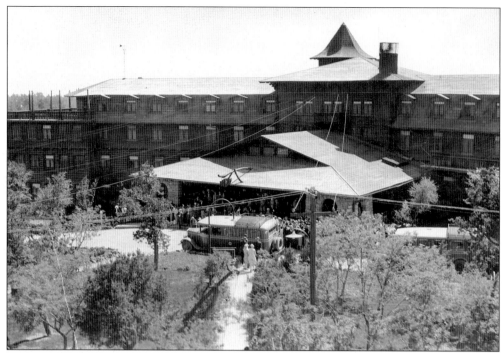

In this 1935 photo, El Tovar porch is seen from the roof of the Hopi House. A shriner group boards tour buses. (GCNP #9651.)

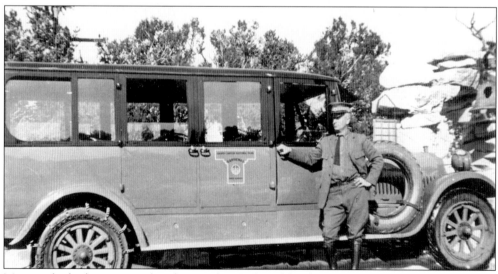

Motor vehicles began to replace buggies by 1915, and by the 1920s, sophisticated touring cars driven by liveried chauffeurs were the norm. William Guy Bass, a Fred Harvey driver, is pictured at Hermits Rest sometime before 1926. (GCNP #17770.)

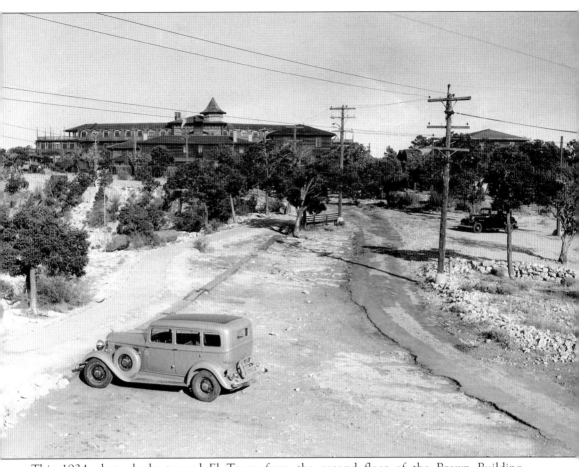

This 1934 photo looks toward El Tovar from the second floor of the Brown Building. (GCNP #9652.)

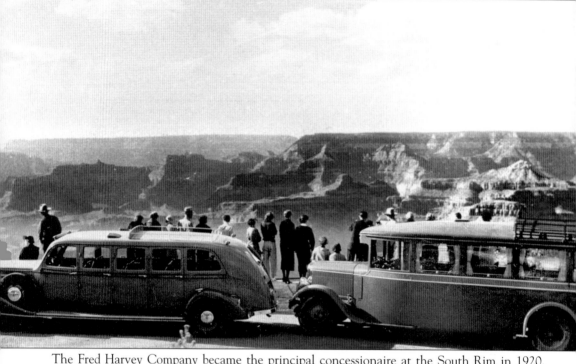

The Fred Harvey Company became the principal concessionaire at the South Rim in 1920. Known as the "Civilizer of the West," Fred Harvey helped make the West more comfortable for travelers. Fred Harvey tour buses parked at Hopi Point. In this 1935 photo, visitors view the magnificent scenery of the canyon in almost a worshipful awe. (GCNP #17730.)

Six

SWITCHBACKS
AND ZIGZAGS

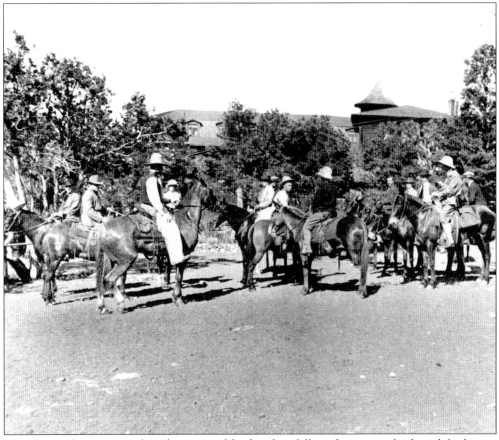

The canyon boasts several trails, or switchbacks, that follow the terrain back and forth in a series of short, sharp angles that turn in alternate directions or zigzags. Saddled up and ready to explore, these riders are about to leave El Tovar for a trip down the trail. (GCNP #17026.)

Surefooted and reliable, mules like these carried people as well as baggage. (Courtesy of the late Edward Aschoff.)

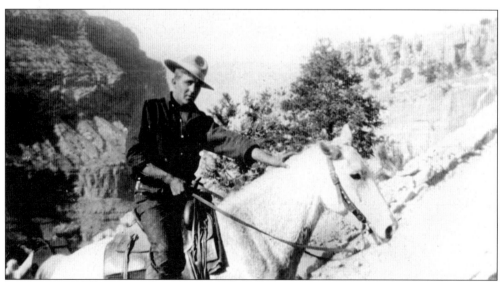

Earl Shirley, a Fred Harvey livery manager, rides a white horse up Hermit's Trail in this 1913 photo. (GCNP #18240.)

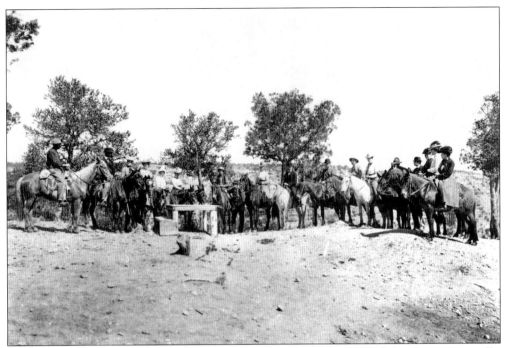

Here, another sizeable trail party is just about ready to leave for a tour down the canyon walls. (GCNP #11338.)

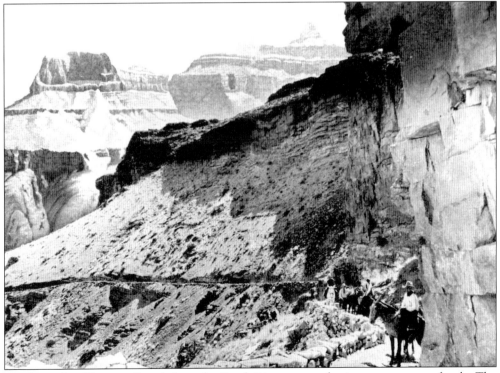

On the trail to Phantom Ranch from the South Rim, one can begin to get a sense of scale. The cliff face rises behind the riders as they look out upon the great chasms below. (GCNP #17031.)

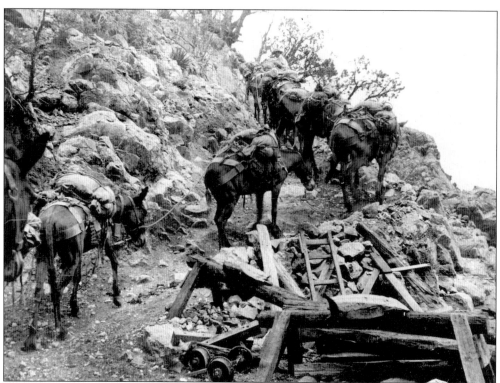

Pack mules climb the switchback of Grandview Trail in this 1905 photo. Note the ladders and wooden barricades. (GCNP #15832.)

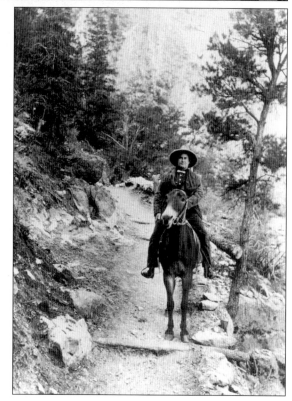

The canyon attracted the rich and famous as well as the common man. Here, in a 1904 photo, is famed attorney William Jennings Bryan on Bright Angel Trail. (GCNP #5564.)

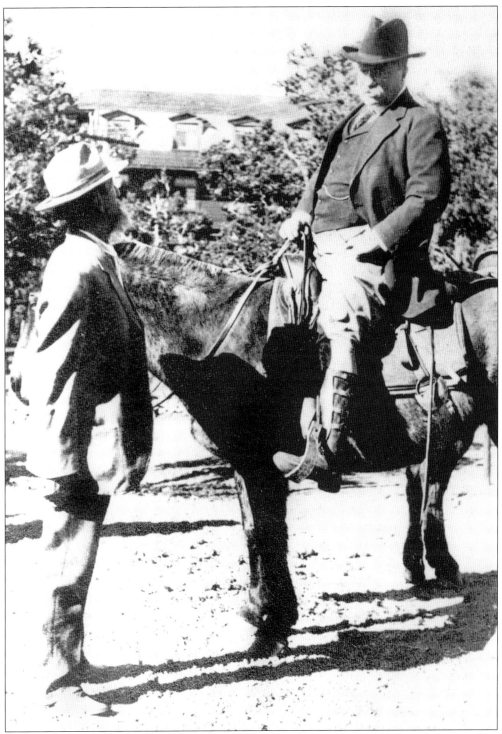

Well known for his passion for adventure and his love of the natural world, President Theodore Roosevelt was no stranger to the canyon. In this 1913 postcard photo, he sits astride a mule near El Tovar. Standing with him is John Hance. (GCNP #1573.)

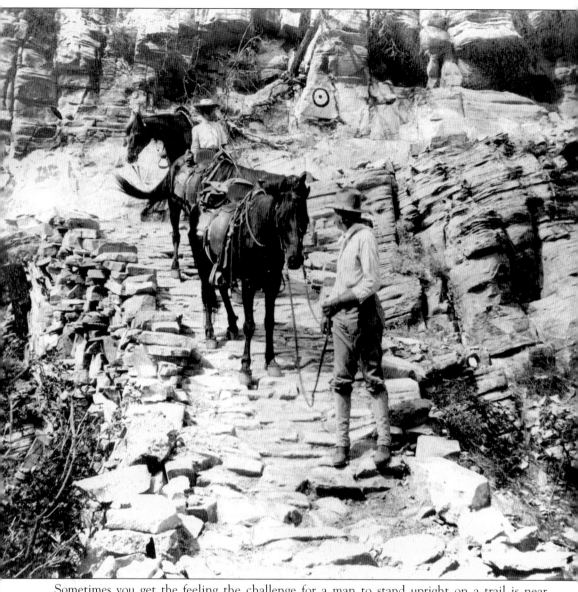

Sometimes you get the feeling the challenge for a man to stand upright on a trail is near impossible. In this 1905, a man leads three horses down a cobblestone section of the Grandview Trail. (GCNP #15830.)

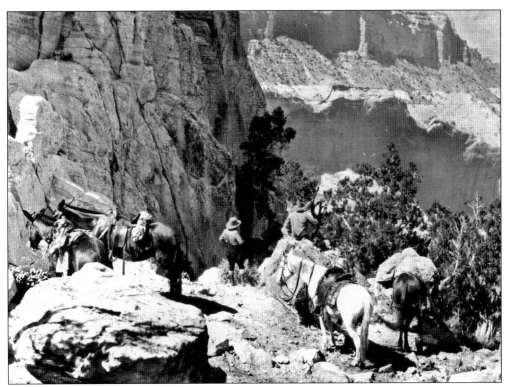

Humphrey Scott captured this
c. 1925 view of some travelers
about to make their descent into
the canyon. Trails such as this
one wind their way down some
4,000 feet, making the return
climb quite difficult. (Courtesy of
the Dudley Scott collection.)

Pictured is a wide view of the
Bright Angel Trail. (Photo by
L.C. McClure, courtesy of the
Denver Public Library, Western
History Collection, call
number MCC-2390.)

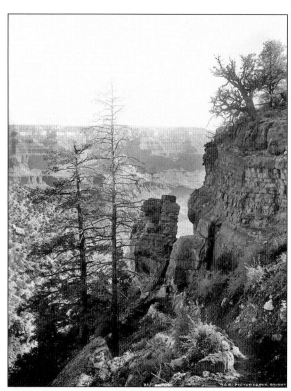

Here is another view of the picturesque Bright Angel Trail. (Photo by L.C. McClure, courtesy of the Denver Public Library, Western History Collection, #MCC-464.)

Although trail riders make their way slowly along the narrow and often treacherous pathways, they have ample time to take in the absolutely spellbinding views. (GCNP #11340.)

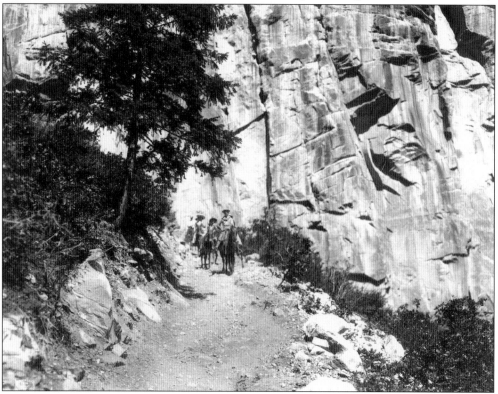

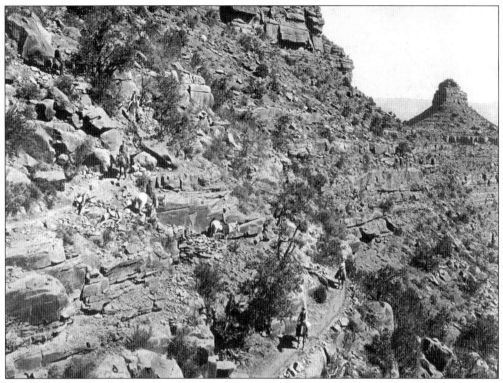

Captain Hance and his party trek along the zigzag of Bright Angel Trail. This picture is worth a thousand words. The terrain is so forbidding that the only way to negotiate travel is by "zigzagging" or "switch-backing" your way along. (GCNP #9834.)

Still high along the trail, a rider captures a magnificent view of his destination far below—Phantom Ranch at the bottom of the canyon. (GCNP #13663.)

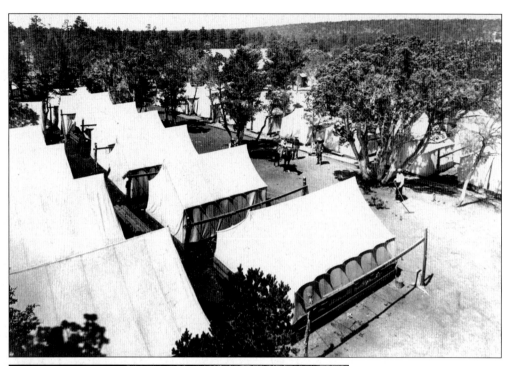

Here is a detail of the Bright Angel Hotel tent area. Again, to get a sense of size and scale, note the man raking in front of the first tent. Other men can be seen conversing with each other in front of the second. (GCNP #11812.)

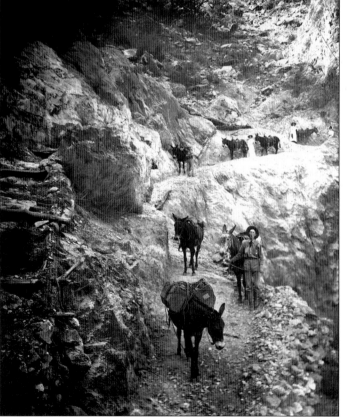

A careful examination of this picture of Jacob's Ladder reveals women (upper right) wearing long dresses, making their way along the path. Such excursions were surely not for the faint of heart or too long of hem! (Photo by L.C. McClure, courtesy of the Denver Public Library, Western History Collection, call number MCC-1188.)

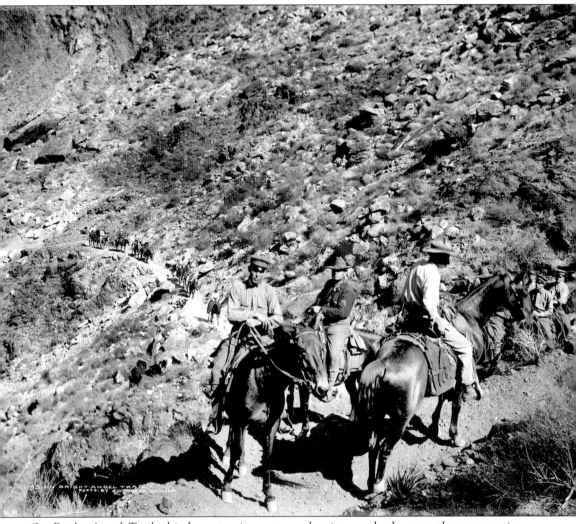

On Bright Angel Trail, this large touring party makes its way back up to the canyon rim. (Photo by L.C. McClure, courtesy of the Denver Public Library, Western History Collection, call number MCC-1193.)

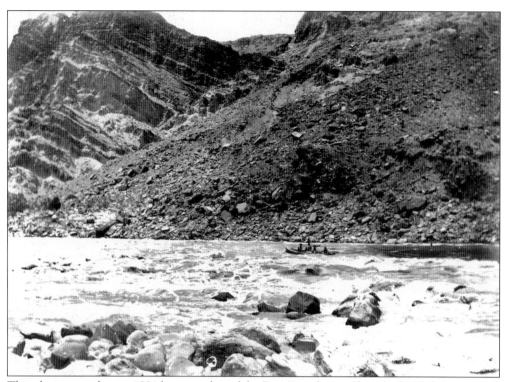

This photo was taken in 1891 by a member of the Best Expedition. If you look carefully, you will see four men in a boat, running the whitewater through Cataract Canyon. (GCNP #18425.)

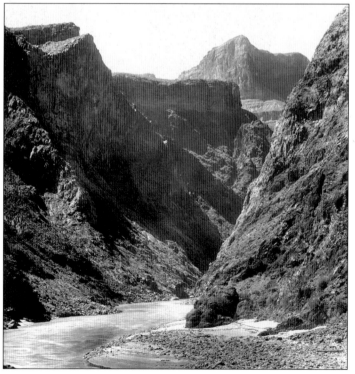

The Colorado River makes its way along the bottom of the canyon. Even in black and white, the photo captures the stunning beauty of sun and shadow, for which the canyon will be forever known. (Photo by L.C. McClure, courtesy of the Denver Public Library, Western History Collection, call number MCC-1205.)

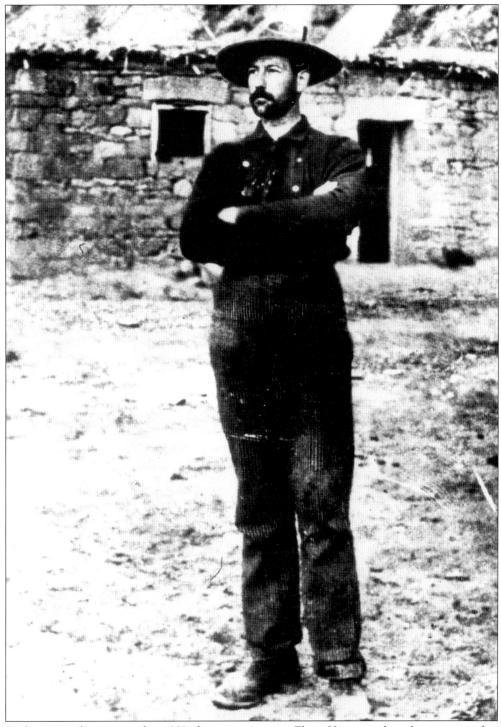

Striking a somber pose in this 1889 photo, river runner Elmer Kane stands with arms crossed at Lees Ferry. (GCNP #18441.)

The Best Expedition poses at Cass Hite's mining camp in this 1891 photo. (GCNP #18432.)

In this 1935 photo of Pierces Ferry, two tour boats are tied on either side to a floating dock on which is a table set for 14 guests. (GCNP #9404.)

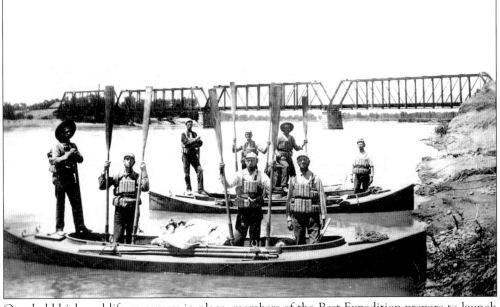

Oars held high and life preservers in place, members of the Best Expedition prepare to launch into the Colorado in this 1891 photo. (GCNP #18415.)

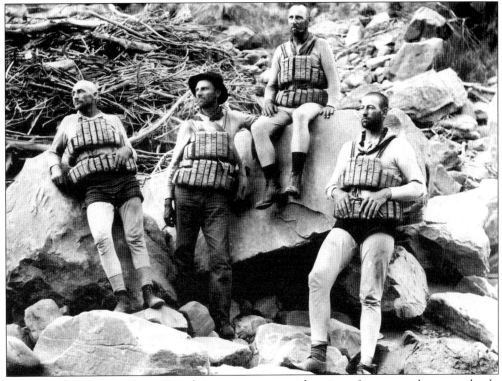

Four members of the Best Expedition gaze out at the river from a rock-strewn bank. (GCNP #18433.)

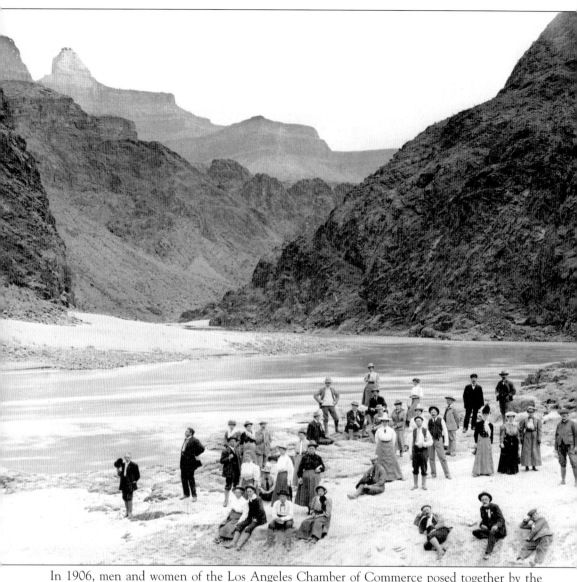

In 1906, men and women of the Los Angeles Chamber of Commerce posed together by the Colorado River, at the end of Bright Angel Trail. (GCNP #13655.)

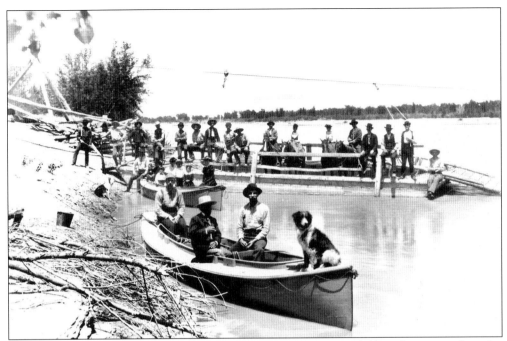

In this 1891 photo, man's best friends—one on the shore (upper left) and one seated on the bow of the boat—are ready to launch. A second boat waits behind the first while a group of riders and their horses watch from a makeshift ferry. (GCNP #18416.)

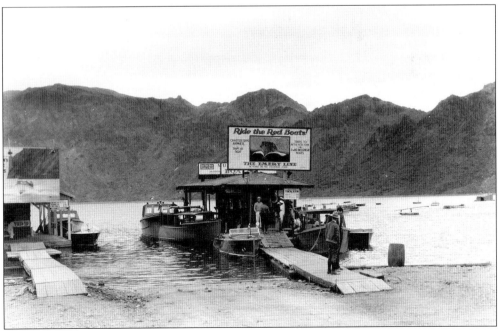

This 1935 photo shows a boat dock on the Colorado River. The sign advertises Red Boat Tours and lists prices. Adults were 75¢; children 40¢. Those were the days, when a penny or so really bought you something! (GCNP #9411A.)

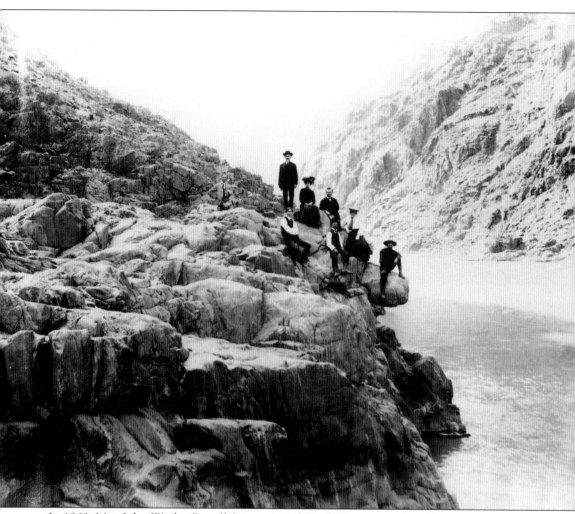

In 1869, Maj. John Wesley Powell (a one-armed Civil War veteran) and his nine companions became the first men to journey 1,000 miles on the Colorado River through the Grand Canyon. Powell's record of his journey, and of his second trip in 1871, provided valuable information about the nature of the Colorado River. In this 1903 photo, seven members of the Edgar Forest Wolfe party take a break by the Colorado River, at the foot of Bright Angel Trail. (GCNP #13728.)

Seven

PAINTED
LIKE A SUNSET

The California Limited, a train of the Santa Fe Railway, advertised the adventure to the Grand Canyon as a trip to a wonderland "a mile deep, miles wide, and painted like a sunset." The picturesque ad worked and drew an ever-growing band of tourists to the land of northern Arizona. In this November 1906 photo, 40 members of the Los Angeles Chamber of Commerce pose on the rim at Hopi Point. (GCNP #13656.)

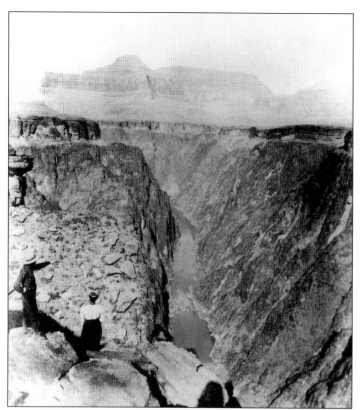

A party on Plateau Point looks west at the Colorado River. (GCNP #13724.)

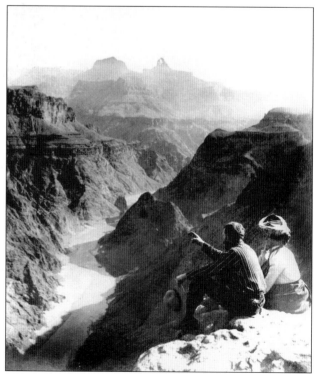

In this 1903 photo, a couple looks east of the inner gorge by Plateau Point. (GCNP #13725.)

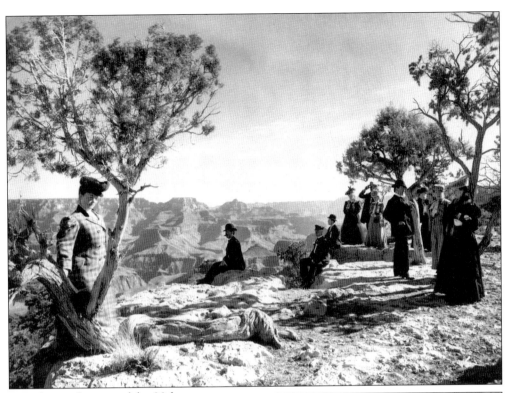

Travelers at the turn of the 20th century were no different than we are today. Here, a party of 1906 tourists pause at O'Neil's Point for some picture-taking memories on the canyon rim. (GCNP #13657.)

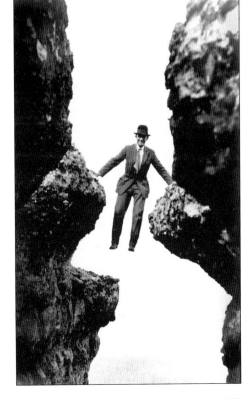

How on earth did he get into this position, and how on earth did he get out of it? We'll never know, but the look on his face is anything but worried. This 1915 outdoorsman is T. L. Brown, a former trail guide, suspended between two vertical limestone walls. One hopes he just did not look down. (GCNP #18193.)

Pause anywhere along the canyon rim and the views will literally stop you in your tracks. Here, three men take in the wide panoramic view of the canyon from Grandview Point. (GCNP #17021.)

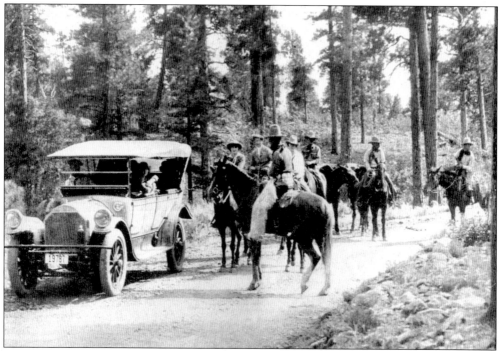

Tourists returning from the Grand Canyon speak of the spectacular views and vistas, and the scent of pine. Here, we see a gathering of tourists amidst the tall and flourishing pines near El Tovar Hotel. (GCNP #17022.)

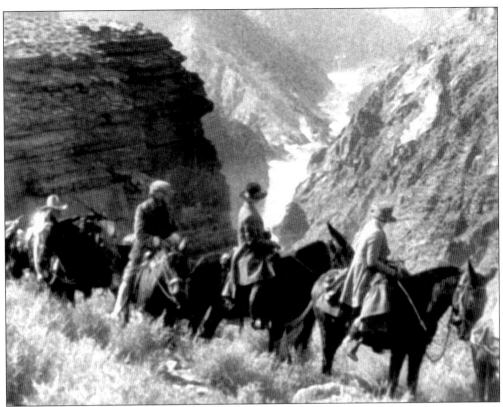

The mules may have "been there" and "done that," but not always so for their riders. Each visitor to the canyon attempts to capture the view and etch it forever in his mind. How did this wondrous place come to be? In this 1922 photo, a Fred Harvey mule party looks from Tonto Trail down inner gorge to the Colorado River. (GCNP #11430.)

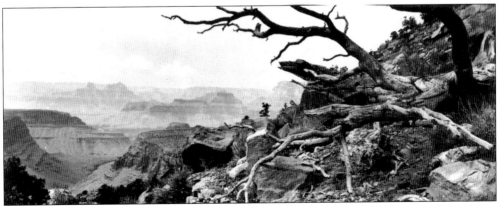

In 1900, as the dark clouds of an afternoon thunderstorm approach, a photographer takes a snapshot looking down Grandview Trail. (GCNP #13729.)

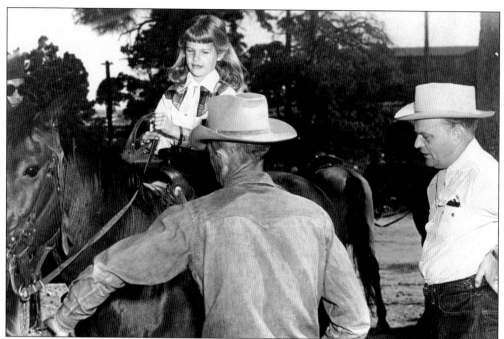

In this 1950 photo, a young Candace Bergen sits on a horse holding the reins as her father, Edgar, looks on. Candace would grow up to be the television character "Murphy Brown;" her dad was famous in the 1940s and 1950s as the sidekick to woodenhead "Charlie McCarthy." (GCNP #17731.)

Another famous television and movie star to visit the canyon was comedian Jimmy Durante. Jimmy is pictured in this 1935 photo with John Bradly, a Fred Harvey guide. (GCNP #17725.)

When Teddy Roosevelt first visited the area in 1903, the canyon so impressed him that he became determined to set it aside as a public trust. Yet it took until 1908 to establish part of the canyon as a national monument. Congress authorized the expansion and upgrading of the monument to national park status in 1919. Roosevelt enjoyed traveling the entire area. Here he is pictured in 1913 at Rust Camp, less than a mile up Bright Angel Creek, near the current location of Phantom Ranch. (Courtesy of the Cline Library, Northern Arizona University.)

Sun and shadow change the canyon's beauty every moment. Here, framed by pine trees, the canyon's shapes and colors are gorgeous. Note the brightest splash of sunlight falling on the rock at the center of the photo. (Courtesy of the late Edward Aschoff.)

An early November snow dusts the ledges of the canyon. (Courtesy of the late Edward Aschoff.)

This view from the South Rim shows O'Neil Butte and Kaibab Trail. (GCNP #5588.)

A wide panorama of the canyon is shown through the limbs of pine trees. (Courtesy of the late Edward Aschoff.)

This view from Kaibab Trail is enough to arrest anyone's attention. The flow, composition, and exquisite detail display the handiwork of Mother Nature like nothing else on Earth. For those who believe in a higher power, a mighty "Amen!" seems justified. (GCNP #5585.)

Eight

OUR NATIVE LEGACY

THE CANYON'S TREASURE

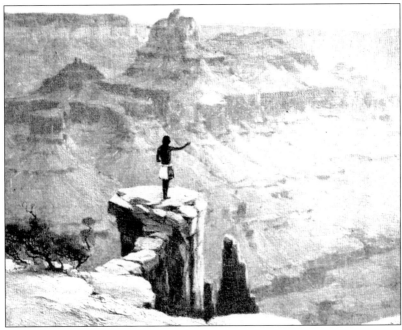

A Native American holy man once said of being old:

> When a man looks back at his many winters, even when they bend him like snow, these things are remembered by the way, and often they seem to be the very tale itself, as I remember them in happiness and sorrow. But now that I can see it all as from a lonely hilltop, I know my life was true; for such things are of the spirit, and it is in the darkness of their eyes that men get lost.

One can only imagine the thoughts passing through the mind of this Hopi man as he gazes out upon the vastness of the canyon and measures it against his own small solitary life. (Photo by H.S. Poley, courtesy of the Denver Public Library, Western History Collection, call number P-1019.)

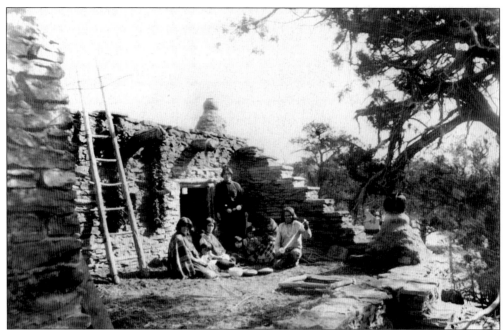

Hopi religion cannot be separated from everyday life. The rituals performed represent the people's role as caretakers of the earth. Their pueblos provided outdoor plazas where they could gather and sing and dance. Hopi artisans on the roof of the Hopi House celebrate a "Native Roof Garden Party" in 1905. (GCNP #9847.)

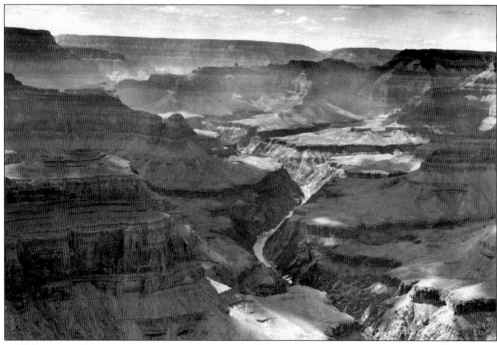

Looking over the vast canyon, it seems impossible that this area could sustain life. Yet for centuries, it has been home to many Native-American groups. This view of the Colorado River is from Pima Point, South Rim. (GCNP #5594.)

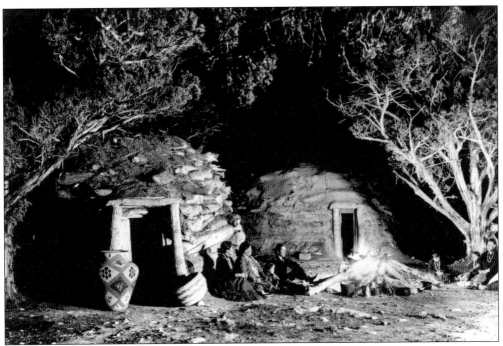

This 1906 photo shows a campfire next to the Navajo hogans adjoining Hopi House. (GCNP #13660.)

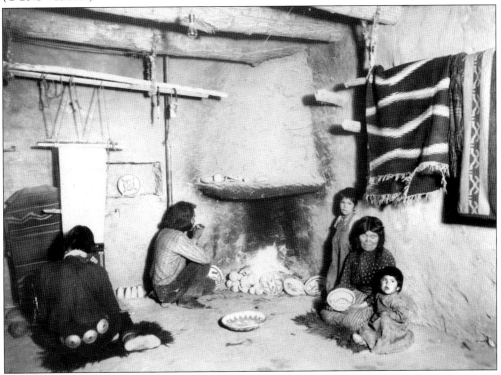

The Hopi are peaceful farmers directly descended from the Anasazi (Puebloans). In this 1905 photo, a Hopi man weaves a sash, and a Hopi potter poses with two children. (GCNP #9826.)

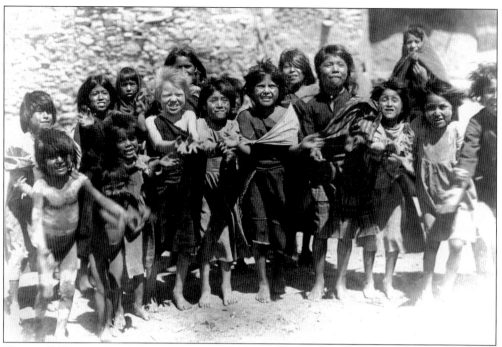

The small Hopi reservation is concentrated in pueblos on three mesas in northeastern Arizona. The Hopi are known for their silverwork, elaborately designed pottery, and kachinas, which are ceremonial spirit dolls. Pictured in 1900 is a group of Hopi children at Walpi. (GCNP #9064.)

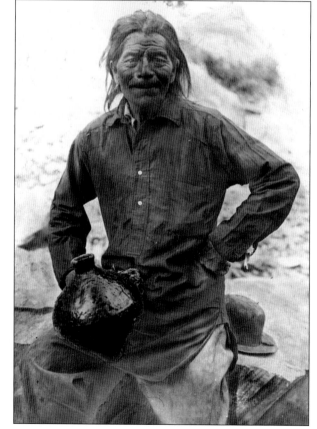

Until the 20th century, the Havasupai led a migratory lifestyle. They moved seasonally between upland plateaus in winter and inner-canyon springs in summer. Here is a 1900 portrait of a noble Havasupai man. (GCNP 10149A.)

The Havasupai Indians of Supai Canyon continue to farm as they have for centuries but also work in the cattle and forestry industries. Men pose outside a brush shelter wearing parts of military uniforms and face paint. Some hold rifles, and one has a fringed gun case. Baskets are displayed in front of them. (Photo by Ben Wittick, courtesy of the Denver Public Library, Western History Collection, call number X-30961.)

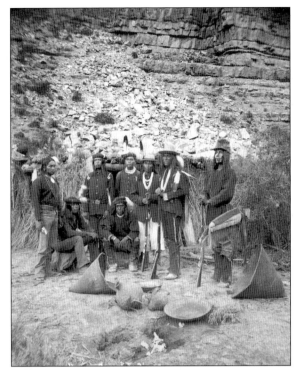

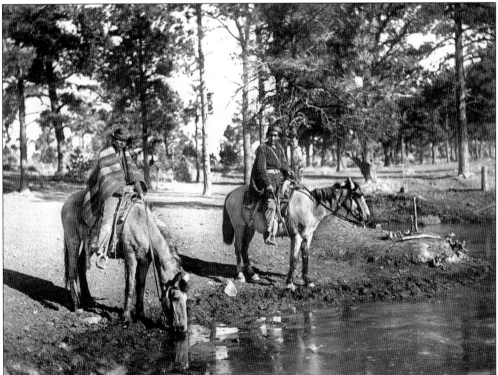

Mounted Navajo men allow their horses to get a drink in this 1907 photo. Horses were revered, and to possess one conferred status. (GCNP #13662.)

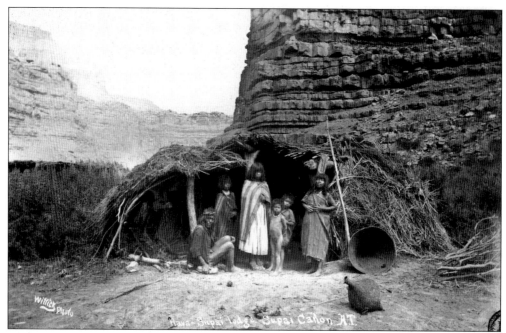

A Havasupi family poses at the entry of their brush shelter. Baskets are displayed in front of them. (Photo by Ben Wittick, courtesy of the Denver Public Library, Western History Collection, #X-30964.)

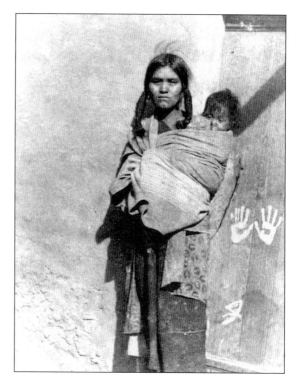

The pueblo mothers carried their babies on their backs, strapped to a cradleboard. In this 1900 photo, a woman sits by the door with her child. (GCNP #9065.)

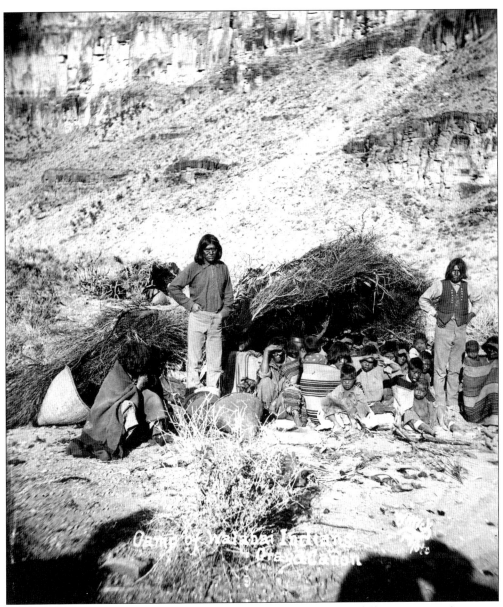

Camp of Walapai Indians
Cataract Cañon

According to the National Park Service, there are currently five different Native-American groups in the area of the Grand Canyon, each with its own language, customs, and beliefs. The Havasupai, the People of the Blue-Green Water, still occupy their traditional lands in Cataract Canyon. The Hualapai live just south of the Grand Canyon. To the east, the park is bordered by the Navajo Nation and the Hopi. The Kaiba-Paiute live north of the Grand Canyon on the Arizona strip, which lies adjacent to Pipe Springs National Monument. The small Hopi reservation is completely surrounded by the Navajo Reservation. The 16 million-acre Navajo Reservation, located near the east entrance of the park, is the largest of any Southwestern tribe. Pictured is a camp of Hualapai Indians. A large group of children and women wrapped in blankets pose huddled under a brush shelter, with a couple of men standing and wearing Anglo dress, work pants, shirts, and buckskin vests. (Photo by Ben Wittick, courtesy of the Denver Public Library, Western History Collection, call number X-31165.)

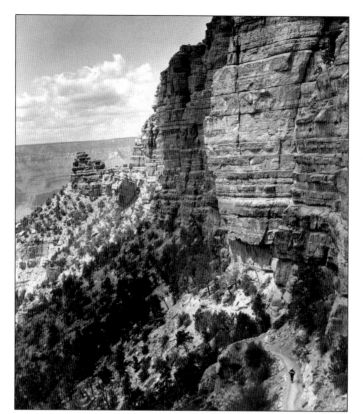

The early residents of the canyon believed that there is good within all things. They had a close relationship with every living thing. Life and spirit lived in the mountains, the rivers, and the sky. Pictured is the Red Wall from Kaibab Trail. (GCNP #5584.)

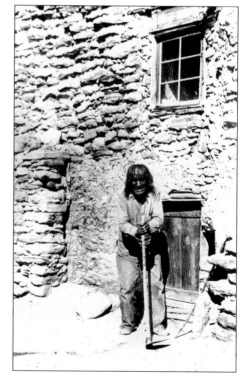

An elderly Hopi man leans on a cane in the Hopi town of Shimopovi in this 1929 photo. It was believed that when a man had three legs, his life was nearly at its end. A cane was more than a crutch for tired legs; it was symbolic of walking long years on the earth. (GCNP #17619.)

124

In this 1910 photo, a Hopi farmer leans against a staff in his cornfield. Corn was a most important crop, not to be plowed. These Native-American farmers would leave a crusty cover of the earth untouched to protect the dampness underneath. (GCNP #15932.)

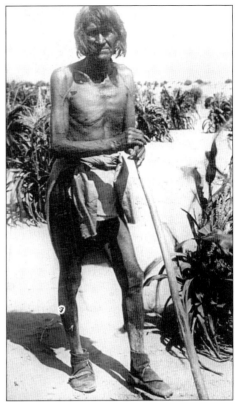

Two pueblo women and a girl grind corn in this 1910 photo. Corn factored heavily in certain Native-American beliefs, with the creation story of several tribes involving corn plants. Many important ceremonial rituals centered around the planting and harvesting of corn. (GCNP #15931.)

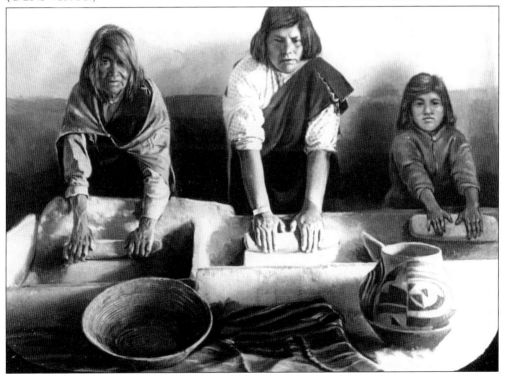

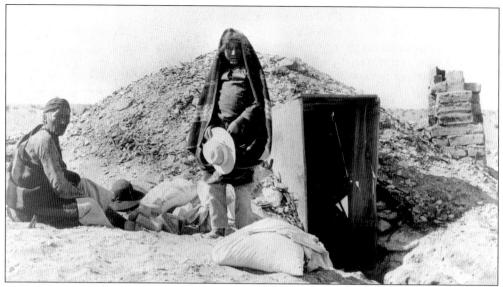

This 1900 photo shows two Navajos are outside of their hogan: a home made of wooden poles, tree bark, and mud. (GCNP #9063.)

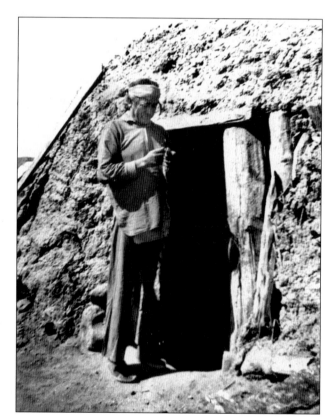

In this 1926 photo, an elderly Navajo man stitches a belt as he stands by the doorway to his mud hogan. The doorway of each hogan opened to the east so Navajos could welcome the morning sun. To awaken and rise with the sun was important to a healthy life. (GCNP #6777.)

A Navajo woman stands by her loom in this 1926 photo. For the people of the Grand Canyon, the loom was an instrument of great worth. Primitive by modern standards, it was years ahead in technology during the period of the ancients. (GCNP #6778.)

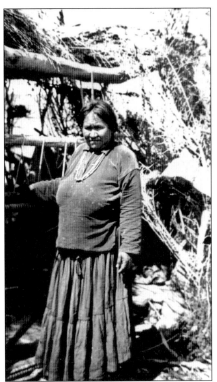

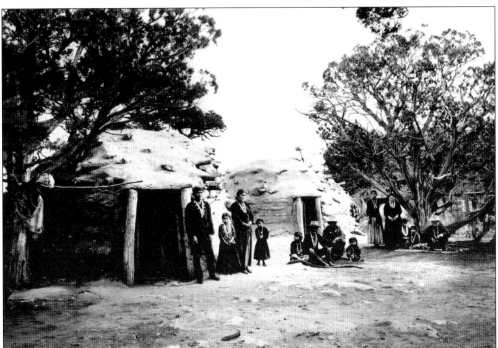

Visitors to the canyon were interested in watching the Hopi artisans weave, make and design their homes. Navajos stand by the hogans adjoining Hopi House and El Tovar Hotel in this 1906 photo. (GCNP #9831.)

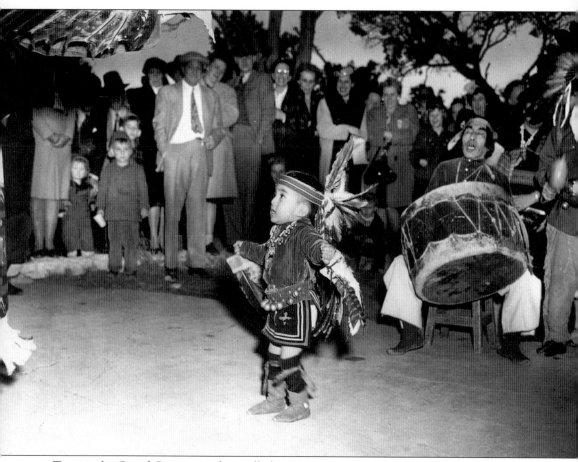

To visit the Grand Canyon is, above all else, a sensory experience. Initially it may be visual as we try to wrap our minds around the awesome and wondrous and ascribe it either to the work of supernatural forces of the universe or to some higher power in one of his most artistic and creative of musings. But it has always amazed me that almost everyone I have met there wants to touch something more personal . . . the lives of the Native Americans who have grown up on this most beautiful land. To appreciate the canyon, one must also appreciate its people. The canyon's history takes human form within them as it is passed down from one generation to another. This 1933 photo captures such meaning as two-year-old Hopi dancer Ronald Timeche performs the eagle dance. He looks to his elders for the story in the dance . . . the story in him . . . the story in us all! (GCNP #9519.)